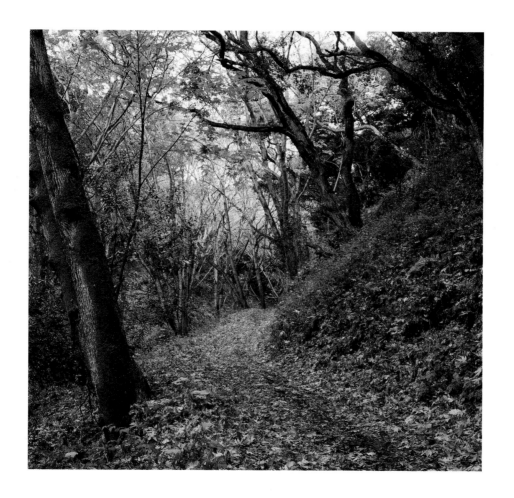

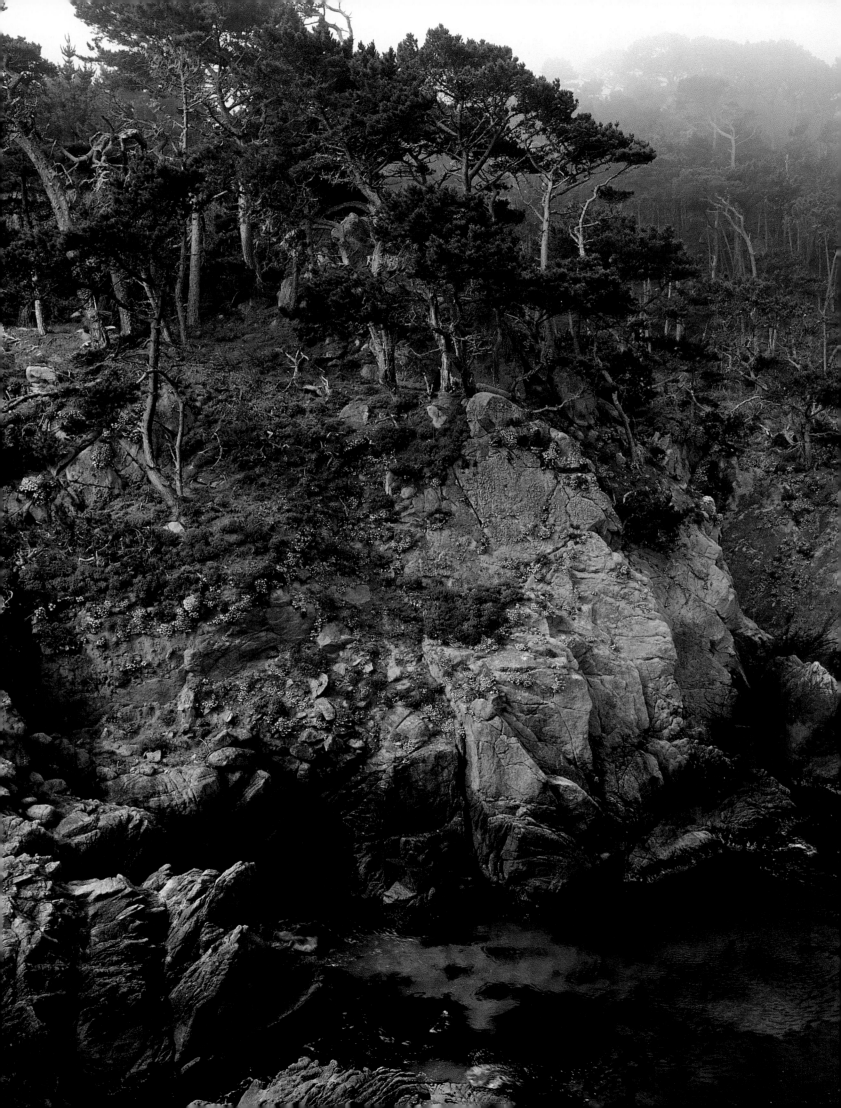

Mary Ellen —
Thanks for all your help.
Come on out & see our beautiful
coastline one of these days.

Gary Geiger

MONTEREY PENINSULA
A Cypress Shore

PHOTOS BY GARY GEIGER ❖ ESSAY BY THOM AKEMAN

GRAPHIC ARTS CENTER PUBLISHING®

To the Brooks brothers—
still chasing images after all these years.

—GARY GEIGER

Special thanks go to Fry Photographics
for their service and great processing.

Photographs © MM by Gary Geiger, except page 21,
which is © MCMXC by Monterey Bay Aquarium and is used by permission.
Essay © MM by Thom Akeman
The quotation from "Tor House" by Robinson Jeffers is
used by permission of Jeffers Literary Properties.
Book compilation © MM by Graphic Arts Center Publishing®
An imprint of Graphic Arts Center Publishing Company
P.O. Box 10306, Portland, Oregon 97296-0306
503/226-2402; www.gacpc.com

Library of Congress Cataloging-in-Publication Data

Geiger, Gary.
 Monterey Peninsula : a Cypress shore / photographs by Gary Geiger ; text by Thom Akeman.
 p. cm.
 ISBN 1-55868-549-9
 1. Monterey Peninsula (Calif.)—Pictorial works. 2. Monterey Peninsula (Calif.)—Description
and travel. I. Akeman, Thom. II. Title.

 F868.M7 G48 2001
 979.4'76—dc21 00-010419

President: Charles M. Hopkins
Editorial Staff: Douglas A. Pfeiffer, Ellen Harkins Wheat, Timothy W. Frew,
Tricia Brown, Kathy Matthews, Jean Andrews, Jean Bond-Slaughter
Production Staff: Richard L. Owsiany, Heather Doornink
Designer: Robert Reynolds
Book Manufacturing: Lincoln & Allen Co.

Printed in Hong Kong

False title photograph: Trails softened by fallen leaves invite the adven-
turesome on intimate explorations of Monterey Peninsula landscapes.

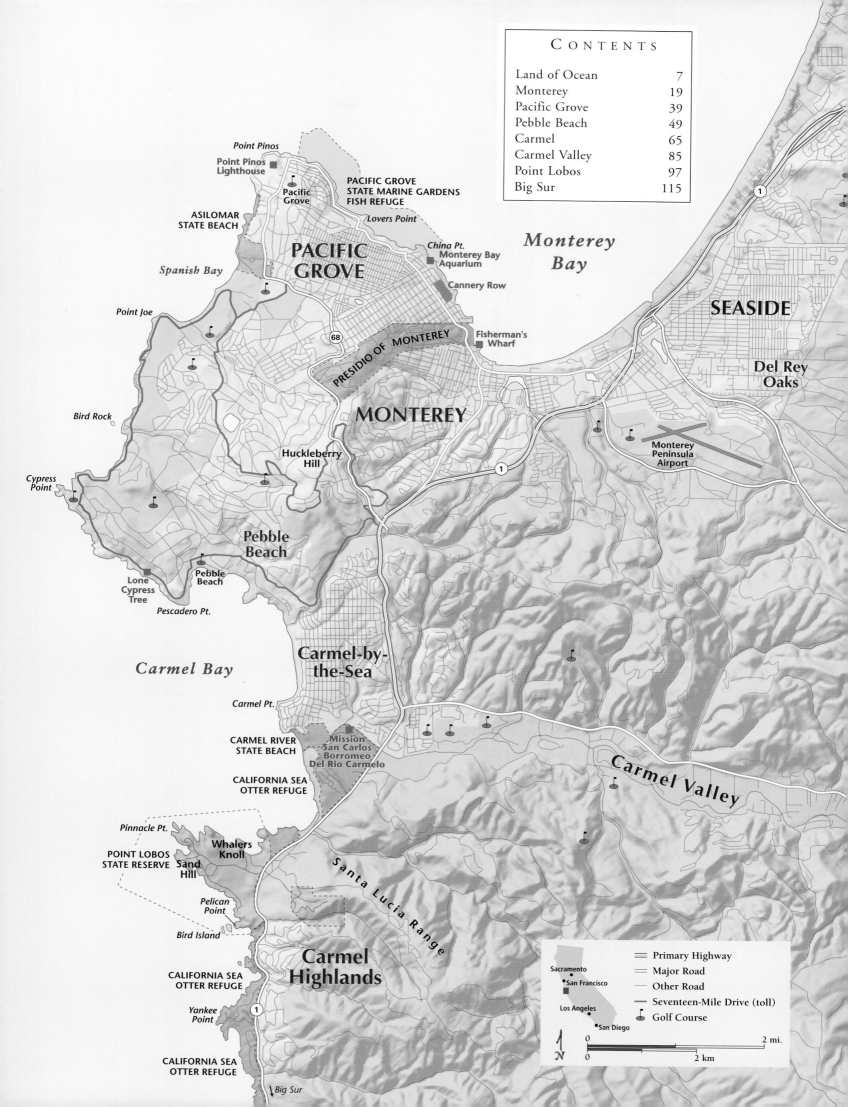

Point Pinos
Point Pinos Lighthouse

Pacific Grove

PACIFIC GROVE STATE MARINE GARDENS FISH REFUGE

ASILOMAR STATE BEACH

Lovers Point

Spanish Bay

China Pt.
Monterey Bay Aquarium

Cannery Row

Monterey Bay

PACIFIC GROVE

Point Joe

68

PRESIDIO OF MONTEREY

Fisherman's Wharf

SEASIDE

Bird Rock

MONTEREY

Del Rey Oaks

Huckleberry Hill

Cypress Point

1

Monterey Peninsula Airport

Pebble Beach

1

Lone Cypress Tree

Pebble Beach

Pescadero Pt.

Carmel Bay

Carmel-by-the-Sea

Carmel Pt.

CARMEL RIVER STATE BEACH

Mission San Carlos Borromeo Del Rio Carmelo

Carmel Valley

CALIFORNIA SEA OTTER REFUGE

Pinnacle Pt.

Whalers Knoll

POINT LOBOS STATE RESERVE

Sand Hill

Pelican Point

Santa Lucia Range

Bird Island

CALIFORNIA SEA OTTER REFUGE

Carmel Highlands

Yankee Point

CALIFORNIA SEA OTTER REFUGE

1

↓ *Big Sur*

Sacramento
• San Francisco

Los Angeles

• San Diego

═══ Primary Highway
── Major Road
── Other Road
━━ Seventeen-Mile Drive (toll)
⛳ Golf Course

N

0 2 mi.
0 2 km

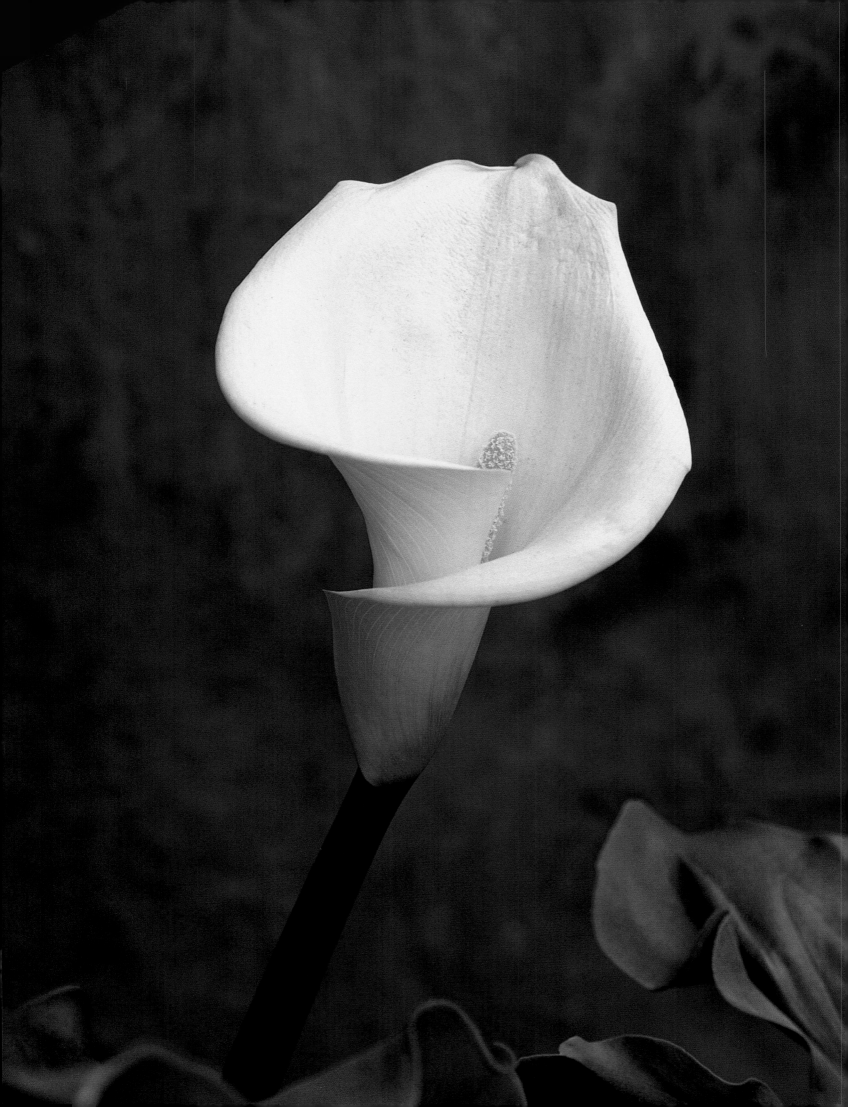

First there was the ocean, that beautiful, treacherous body of life. Then the ocean floor rose up to form the land, with such interesting shapes and patterns that only the forces of nature could have designed them. Eventually the people followed.

It has taken millions of years of evolution—pelagic, geologic, biological, and cultural—to create the Monterey Peninsula of today, a charming series of communities that appeal to bare-butt, stoned-out hippies as much as to some of the wealthiest and most talented people in the world.

These communities share a natural wonderland of rocky coast lined by forested hills and fertile valleys, shapes that strut and rim, greens of every lush shade, and wildflowers of every radiant color.

Year-round golf is a draw for some, the warm days and cool nights for others, the beaches for many, the spectacular sunsets and the endless ocean for almost all. The pounding surf is nature's own heartbeat.

There is also the town of Monterey, a place full of history and reminders of the past. Monterey, or the land that became Monterey, was first occupied by people who thrived in a climate moderated by the ocean and lived on the seafood from it. Sixteenth-century explorers sailing the Pacific Ocean eventually landed in that pristine world. And then the European settlers came, and the rest, as they say, is history.

Adjacent Pacific Grove, the quiet community on the Monterey Peninsula, was founded by San Francisco church members who wanted to use one of the area's rocky outcroppings for revival meetings by the sea.

Pebble Beach, made world famous by its golf courses and photographs of their tees and greens on a mesmerizing coastline, was originally the backdrop for oceanside rides and scenic views for guests of a posh Monterey hotel.

Carmel has become a sought-out resort because of its gorgeous setting on Carmel Bay, its European village flavor, and the utter charm of picturesque cottages peeking out through tall trees. Carmel-by-the-Sea, as it is officially named, was popular with the rich and famous even before movie idol Clint Eastwood served a term as mayor in the late 1980s.

Carmel Valley, nestled in the hills from which it was carved, is the ranch and sunshine capital of the Monterey Peninsula, offering breaks from the ocean fog and drizzle that sometimes cloud the neighboring communities jutting out on the tip of the rocky peninsula.

Big Sur, a place where God would live, has collected an eclectic mix of rich and poor in a mystical area of tree-covered hills that plunge right down into the crashing surf. This is a place known for its endless vistas, its extreme practice of the live-and-let-live philosophy, and its potent marijuana plants.

The Monterey Peninsula is a magical place that many consider paradise. It boasts vantage points for viewing the thousands of whales that swim past the peninsula each year; overlooks for observing playful sea otters, noisy sea lions, and sleepy harbor seals; clearings for watching the many birds that fly and feed in the area; and open areas for studying the many deer and other animals that roam free.

Much of this area has been preserved in its natural state by federal, state, county, regional, and city governments, along with a lot of help from foundations, nonprofit organizations, businesses, and supportive individuals. Most of the forests that fill Big Sur are controlled by the federal government, which restricts access primarily to hikers and backpackers. The state of California maintains Point Lobos, with its incredible array of geology, plants, and animals, as a nature preserve. The federal and state governments, the Pebble Beach Company, and the cities of Carmel and

◁ *The calla lily's delicate, snow-white, velvety trumpet has decorated countless weddings and inspired any number of photographs and paintings on the Monterey Peninsula. Calla lilies flourish year-round wherever there's enough soil, moisture, and shade.*

Pacific Grove own most of the shoreline on the Monterey Peninsula and keep it as open space, parks, and public beaches. Large parts of Carmel Valley, Monterey, Pacific Grove, Carmel, and Pebble Beach are also preserved for nature and gentle exploration.

But the biggest preserve of all is the ocean. The Monterey Bay National Marine Sanctuary, established in 1992 after twenty years of political debate, provides special legal protections for a five-thousand-square-mile section of the Pacific Ocean that stretches along the Monterey County coast and one hundred miles north to San Francisco. The water quality, the marine life, and the ocean floor are all protected as areas of special concern, particularly for about twenty research institutions, marine science organizations, and universities that depend on pristine conditions for the cutting-edge work they do in Monterey Bay.

The beauty on the surface is obvious to anyone. But beneath the water, scientists using submarines and remote cameras have discovered more than fifty types of animals never before known to exist. Many of them are gelatinous animals vitally important in the food chain and now believed to be common in the deep, cold parts of the ocean. Others— such as clams in the deepest, darkest parts—live on toxins emitted through the earth's crust and may be crucial in keeping the ocean clean for the marine life we know about.

This fascinating research has centered here because of a unique land formation that cannot be seen from the shore. The Monterey Canyon, as it is called, is the largest submarine canyon on the West Coast. Formed eons ago as the drainage for a massive inland lake, the canyon cuts a deep channel that has branched and spread to form what we named Monterey Bay. The canyon starts within wading distance of a village named Moss Landing and runs for at least forty-five miles into the ocean, winding past smaller canyons and cutting as deep as ten thousand feet below sea level. Its dimensions are similar to the Grand Canyon in Arizona and Utah.

Its proximity to land allows marine scientists to go out in the morning for a day of deep-sea research and be home in time for dinner. Most research of this nature requires days of sailing to reach deep waters, then days to return to shore.

Beyond the convenience for researchers, the Monterey Canyon is an essential source of life for Monterey Bay, sending up the cold water and nutrients that support the unusually diverse community of plants and animals in the bay. Restaurant menus in the area may be rich with the salmon, squid, and prawns that the bay routinely provides, but there are also dolphins, blue whales, an amazing range of jellyfish, colorful snails and plants, and more than five hundred other species such as those on exhibit at the renowned Monterey Bay Aquarium in Monterey.

Even the rich soil of the Monterey Peninsula comes from the crust of the underwater canyons. Deposits from the ocean floor sit on top of pebbles and cobbles that came from inland formations, which are on top of the granite base that gives the peninsula its underlying shape and strength. Geologists tell us the granite was formed by volcanic action at least thirty million years ago, three hundred to four hundred miles south of where it now forms a peninsula into the ocean. The granite broke off from the southern Sierra Nevada and moved up slowly on the Pacific Plate, the tectonic plate that carries most of the Pacific Ocean. This granite was under water for a very long time, rising out of it a million or so years ago, carrying up the pebbles and sediments from the ocean floor.

This unique formation has given us picturesque beauty, a diverse animal kingdom, and a natural world that can take us to forever. And it all comes back to the ocean.

▷ *Few relics remain of the old Cannery Row in Monterey. During the boom years of the early 1900s, two dozen canneries processed thousands of tons of sardines. This cannery was torn down to make room for the Monterey Bay Aquarium.*

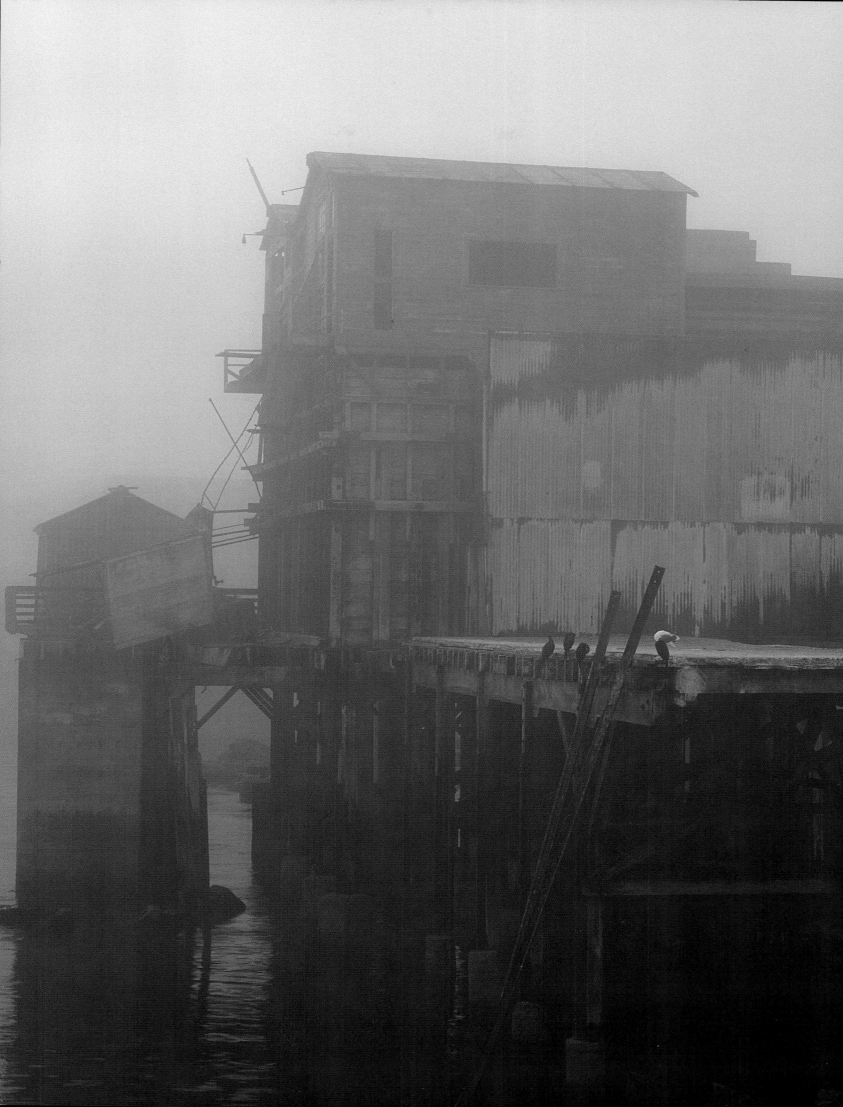

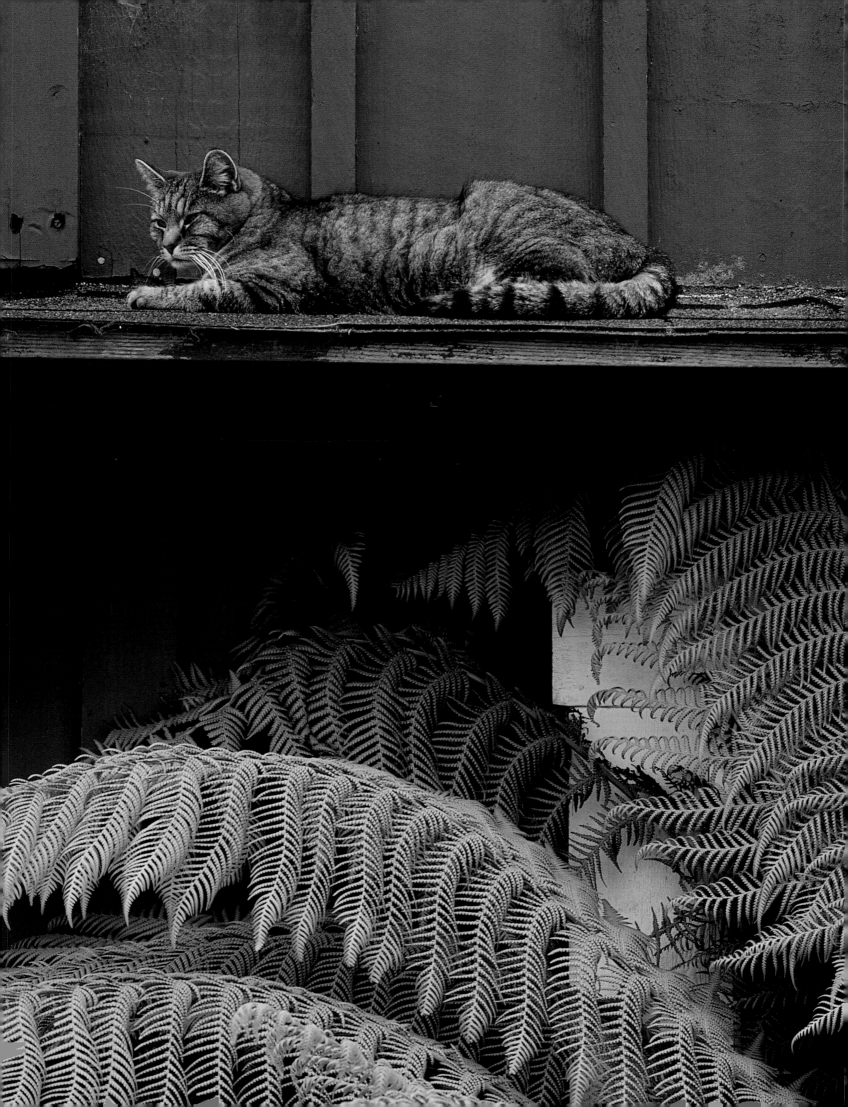

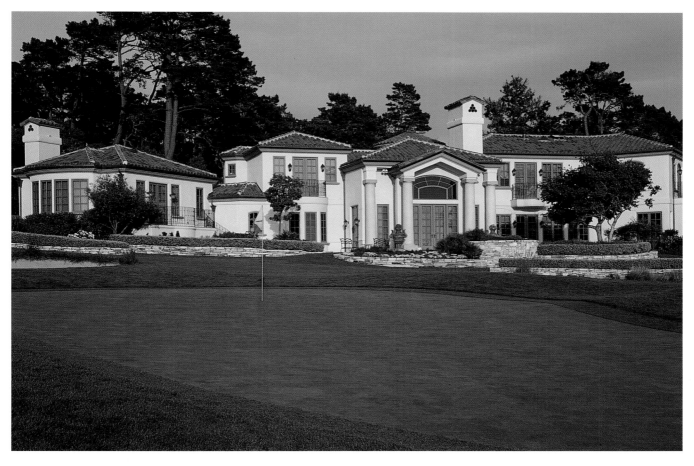

◁ A tiger cat has found a peaceful perch at the base of one of the
old board-and-batten houses of Pacific Grove. For now, it oversees
a forest of ferns made lush by the ocean fog that kisses the area.
△ One of the newer mansions in Pebble Beach sits on the eleventh
green of the famed Pebble Beach Golf Links.

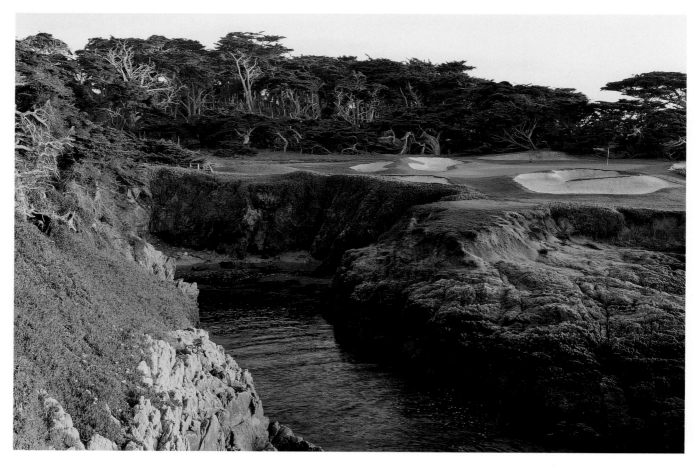

△ The fifteenth hole of the Cypress Point Club's golf course sits on an exquisite outcropping stretching into the Pacific Ocean. ▷ Monterey cypress trees line the shore, their gnarled branches shaped by the strong winds and the salt spray off the ocean.

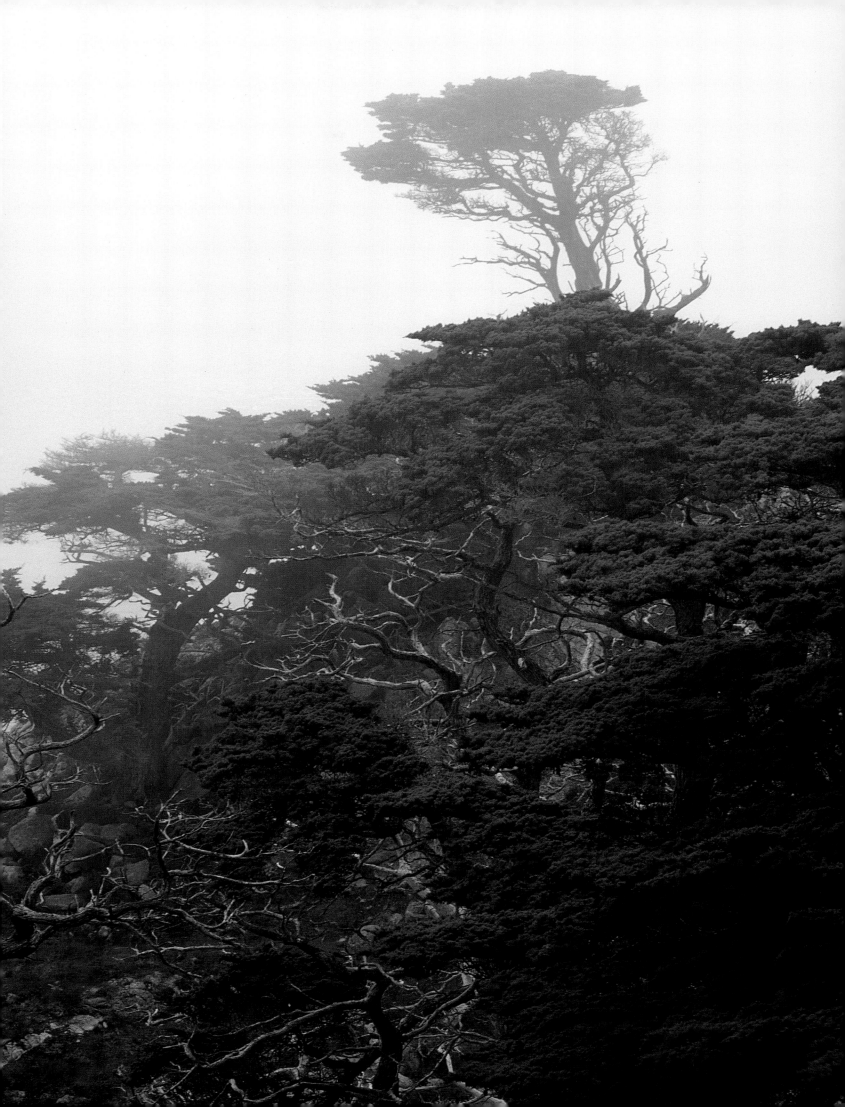

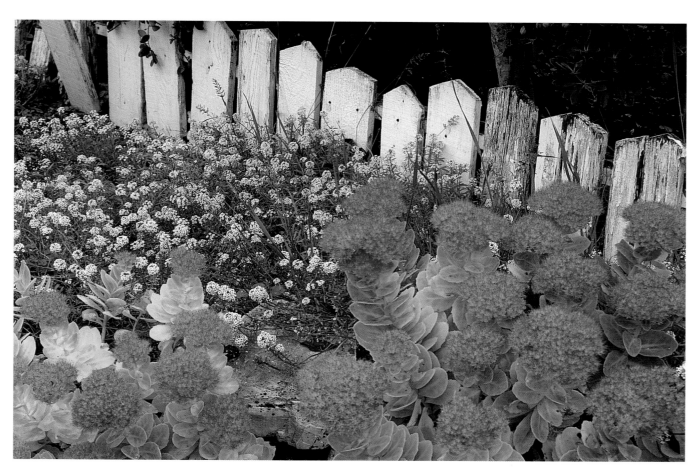

◁ Carmel-by-the-Sea's picturesque cottages, most of them con-
structed from stone or wood, give the town a European flavor.
△ Flowers, bright and fresh, add delightful color to a garden
bordered by a picket fence characterized by age and weather.

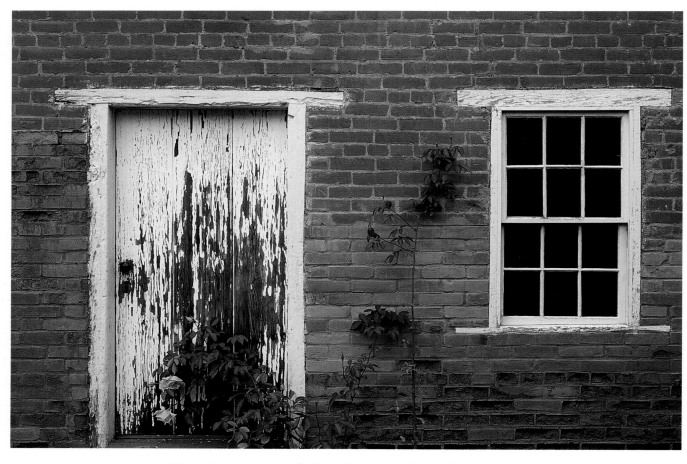

△ More than 150 years of salt air have toned the walls of Monterey's First Brick House. Near Fisherman's Wharf, the home was built in 1847 with bricks fired in a kiln, a new technology in an area that had relied on packed adobe and timbers for its structures. ▷ Situated in downtown Monterey, the Cooper-Molera Adobe's windows have shutters that still close at night, just as they have since the place was built in 1827.

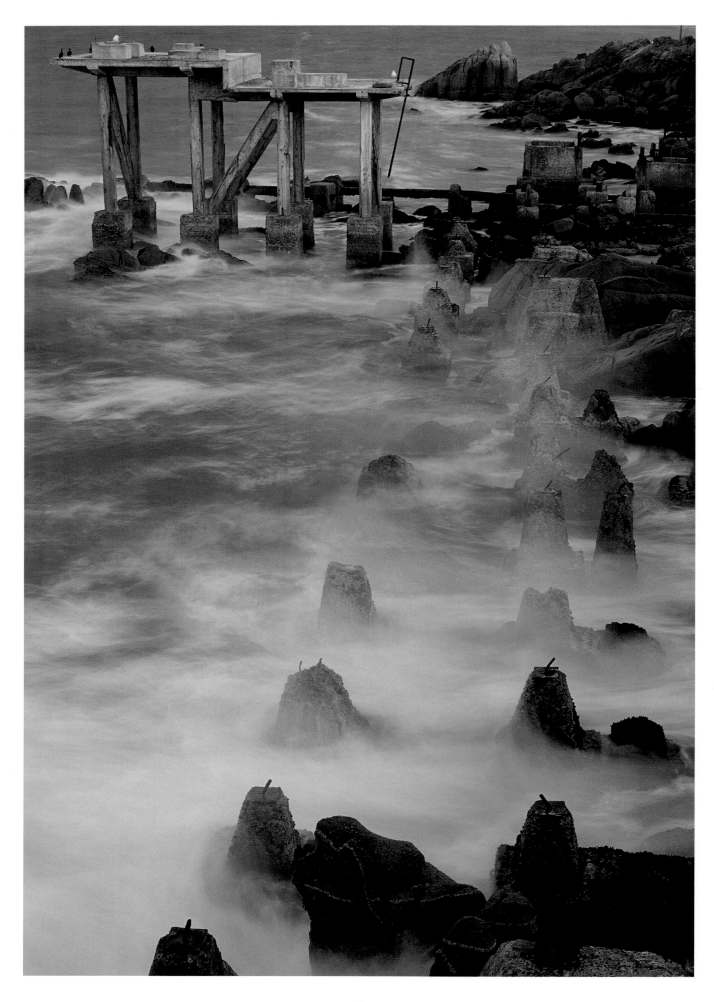

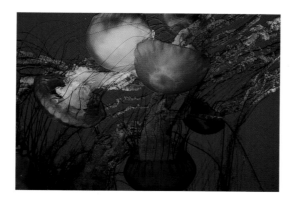

There is no escaping the rich history of Monterey. The vestiges of Spanish settlement, Mexican rule, and U.S. expansion—with its ranching, fishing, military activities, and tourism—are preserved in old structures that are simply too numerous to overlook.

The earliest surviving building in Monterey is a beautiful adobe that's more than two hundred years old. A Catholic church, now called the San Carlos Cathedral, it was built in 1794 by Spanish missionaries and the Ohlone Indians who worked for them.

Yet even the oldest building is actually a remnant of what might be considered the third stage of the history of Monterey. This history actually goes back centuries before, and if we trace it to the first documentation that exists, we uncover connections to the settlement of the entire West, the expansion of the United States, and the creation of the state of California—all in Monterey.

Two thousand years ago, the Ohlone, as they called themselves, were the only people here. The Spanish who happened upon them later named them Costanoans for "coast people." The Ohlone had migrated from the north a few hundred generations before the Spanish arrived and thrived in the mild climate of Central California, utilizing the abundance of animals, seafood, seeds, and plants.

But the Ohlone didn't build with three-foot-thick adobe walls and tile roofs as the Spanish settlers did, so they left no structures behind. Rock tools, such as granite mortars used for grinding acorns into flour, and an occasional grave that can be carbon-dated back thousands of years are about the only physical reminders that the Ohlone were here first.

The second stage of Monterey history didn't leave any structures behind either. It left only journals and maps,

◁ Concrete pilings, once under the sardine canneries of Monterey's liveliest era, still hold up in surf that has hammered them for a century. Time has blended them in with the shoreline's granite rocks, making them seem just another part of nature's beauty.

written after Europeans and their sailing ships began to reach the new world.

A Portuguese navigator, Juan Rodriguez Cabrillo, was the first to map the area—in 1542, just fifty years after Christopher Columbus landed on the East Coast. Cabrillo wrote down his sightings and mapped the crescent bay, giving us what would eventually become known as the first recorded history of California.

Sixty years later, in 1602, the first European landed in Monterey. Spanish explorer Sebastian Vizcaino claimed the area for Spain and named it Monterey in honor of his patron, the Count of Monterey. Vizcaino didn't stay, nor did he leave any structures or known artifacts behind. He did, however, pass along detailed maps to Spanish galleons, which might need to stop on their runs between Mexico and the Orient. As far as we know, none ever did.

It was another 168 years before the third stage of Monterey history began, the one that brought the missionaries who started to build more permanent structures. Gaspar de Portola landed near what is now the Artillery Street gate of the Presidio of Monterey on June 3, 1770. He brought Father Junípero Serra, the mission builder, and a group of Spanish soldiers who founded the presidio that today houses the Defense Department's foreign language school.

The Spanish were trying to colonize what they called "Upper California" before the Russians—who were moving down the West Coast killing sea otters for their thick fur—got to it first. And the missionaries were intent on spreading their religion to the friendly Natives. They brought the Ohlone into the mission to work for them and to learn their language and religion, voluntarily at first, and then later by force.

The priests relocated the mission from Monterey eighteen months after it was founded, partly to separate the Indian women from the Spanish soldiers. They moved it three miles away to a more fertile site on the Carmel River, creating the Carmel Mission, the second permanent settlement in the area.

More settlers and the first herds of livestock arrived in

1776, after Juan Bautista de Anza led an overland march from Mexico to Monterey and the San Francisco Bay area.

Most of the original buildings of Monterey were destroyed in 1789 when misguided cannon fire set them ablaze. The San Carlos Cathedral that still stands—called the Royal Presidio Chapel when it was built in 1794—was made from sandstone, then covered with clay-and-straw adobe. Spanish rule ended in 1822, after Mexico revolted against Spain and became an independent nation. The Mexicans took over California as a new province and started the fourth stage of Monterey's history. They turned Monterey into a government and commercial center and built the Custom House at the harbor in 1827 to collect taxes on the cowhides and tallow that were being shipped out.

During twenty-four years of Mexican rule, approximately one hundred adobe houses were built near the harbor, extending the settlement about three blocks in any given direction. Thirty-four of these adobes still stand and are used today as museums, offices, clubhouses, and restaurants.

But the Mexicans lost interest in their remote outpost, and had pulled out their officials and troops by the time the Americans arrived in 1846 to claim California and start the fifth stage of Monterey's history.

A U.S. Navy commander named John Drake Sloat had three ships of cannons, and 250 sailors and Marines for a landing party. But they had trouble finding any lingering Mexicans to surrender the place to them. They simply raised a few flags on July 7, and the United States was stretched from one coast to the other.

The first American magistrate of Monterey was Walter Colton, a retired Navy chaplain who sold building lots and put fees on vices—taxes on liquor, fines for gambling—in order to get money for the new government. He used convicts to quarry sandstone (which was actually shale that was once mud on the ocean floor—known today as Carmel stone, or chalk rock) and build a town hall and schoolhouse. The stately, two-story building, which is now part of the City Hall complex, was completed in 1849, in time for forty-eight delegates from around California to gather and hammer out a constitution for a new state. The bilingual document—forty of the signers were English-speaking, eight were Spanish-speaking—was signed on October 13, 1849, just before the gold discovery that sparked the rush to California.

The gold rush bypassed Monterey, which turned to smellier industries. Portuguese immigrants in the 1850s caught passing whales, dragged them onto the beach, cut out their blubber, boiled it down to get the oil out of it, and exported it by the hundreds of barrels. Carcasses and bones were left to rot on the beach. This bloody industry lasted about thirty years before the whales disappeared.

Chinese immigrants arrived next. After work in the gold mines and on the railroads ended, many moved to Monterey to escape from the discrimination of white laborers who were worried about competition. The Chinese established a colony on the beach of what is now Pacific Grove, built a few dozen boats, and caught shrimp and squid, which they dried on their rooftops and in nearby fields, and then exported to China. Soon they were shipping two hundred thousand pounds of seafood a year and stinking up the area with the stench of the processing, which evoked animosity from the white fishermen and the real estate developers who were emerging in Monterey and Pacific Grove. The city adopted ordinances to ban Chinese from bay waters and to keep them from catching shrimp and shipping it to China. The state passed a law to keep the Chinese—and all Asian immigrants—from owning property.

Tourism started in 1880, when Monterey had only two or three streets paved with beach sand and a few wooden sidewalks on Alvarado Street. Railroad tycoon Charles Crocker built a posh hotel to help fill the trains from San Francisco. It was a three-story structure with a red tile roof, spires and turrets, an ornate ballroom, wrap-around porches, gardens that included a maze for playing hide-and-seek, gravel trails through the forest, polo fields, and a horse-racing track. He

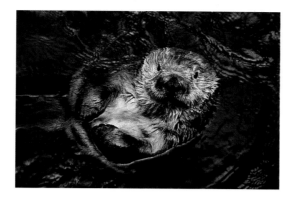

named the four-hundred-room resort Hotel Del Monte and advertised it as "the most elegant seaside resort in the world."

The hotel attracted the rich and famous and thrived until the Depression years. The Navy took it over in World War II and turned it into the Naval Postgraduate School, an institution now devoted to the research of space and virtual reality.

The Hotel Del Monte built the first golf course on the Monterey Peninsula. The course is still in play, but it now belongs to the Pebble Beach Company and sits across Highway 1. The polo fields and horse-racing track are now the city-owned fairgrounds.

Other industries emerged while wealthy tourists flocked to the resort. The railroads that owned what is now Pebble Beach started mining the white beach sand and shipping it to glass factories. And Japanese immigrants learned to dive for abalone, and then dry and ship it to markets in Japan and China before laws banned this practice.

All the natural harvesting to that point was about to be upstaged by a fish cannery that opened in Monterey in 1902. Frank Booth thought he could can the pilchards that were plentiful in Monterey Bay and find a market for them somewhere in the world. The pilchards, better known as sardines, eventually brought riches and a colorful era to Monterey, a smelly era that provided fodder and characters for writer John Steinbeck, who did more to make Cannery Row famous than the fishermen or the canneries ever did.

At its start after the turn of the twentieth century, there wasn't much to the now-famous Cannery Row, which was originally named Ocean View Boulevard.

The Monterey Fishing and Canning Co., situated on property that is now a city-owned parking lot for recreational vehicles, was alone in business for fourteen years. It operated only part-time and attracted but a handful of Sicilian fishermen to the area to cash in on the sardines and start building families that have since become prominent.

It wasn't until World War I that the boom started on Cannery Row. The war created a need for canned protein that could be used as rations for front-line soldiers. Fishermen—Sicilian and Japanese—flocked to Monterey by the hundreds as seven more canneries opened during the war. Three of those buildings are still standing today, including the Monterey Canning Co. complex built in 1918—two large buildings linked together by a wooden bridge elevated over the street between them.

More canneries opened during the 1920s when rising salmon prices expanded the market for sardines. And a community developed around Cannery Row, a community ready for more canneries that popped up in the Depression to process cheap fish. World War II produced another half-dozen, bringing the count to twenty-three at its peak, crowded together tightly on a street that is only four blocks long.

Fish oil was actually the major product, as well as fertilizer made from the leftovers. That accounted for about two-thirds of all the sardines caught, and it left piles of fish to rot and make Monterey famous for its stink. It was such a pervasive, foul odor that people are only now forgetting about it.

The sardine catch got bigger, of course, and peaked at half a million pounds a year before the fish disappeared. They were gone by 1948; the canneries that lingered had to truck in fish from Southern California in order to have anything to process.

The last cannery hung on until 1973, operating only part-time on what was practically an abandoned street with potholes almost as big as cars. The skeleton of this building was eventually torn down to make room for the Monterey Bay Aquarium.

The aquarium opened in 1984 and sparked a tourist boom that created a new, robust economy for Monterey. There were only twelve hundred hotel rooms in the city before the aquarium opened, many of them used by people visiting the military bases that dominated the local economy at the time. Today there are more than nine thousand hotel rooms in the area, and six million tourists visit each year, a third of them going to the aquarium to explore the more than five hundred species of marine life found in the adjacent Monterey Bay.

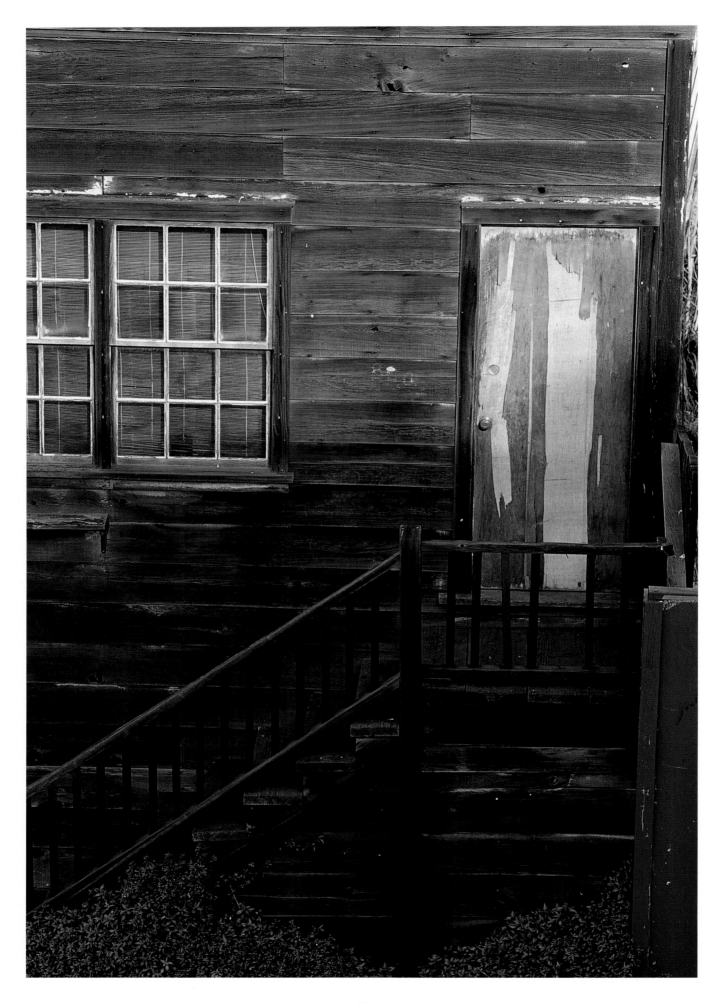

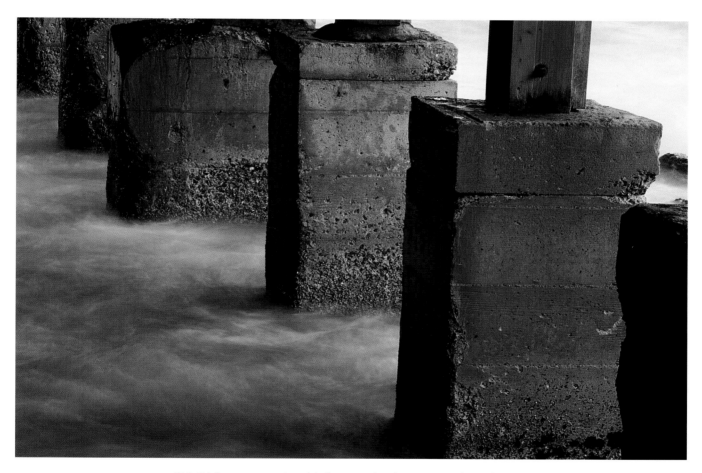

◁ Ed Rickets, a marine biologist who became a close friend of novelist John Steinbeck and was the model for Doc in the colorful *Cannery Row,* lived and worked in this small building on the Row. △ These concrete pilings hold a popular Cannery Row restaurant that juts out over the water. They have been maintained and upgraded over the years to enable them to withstand the weather and the pounding they take from the surf.

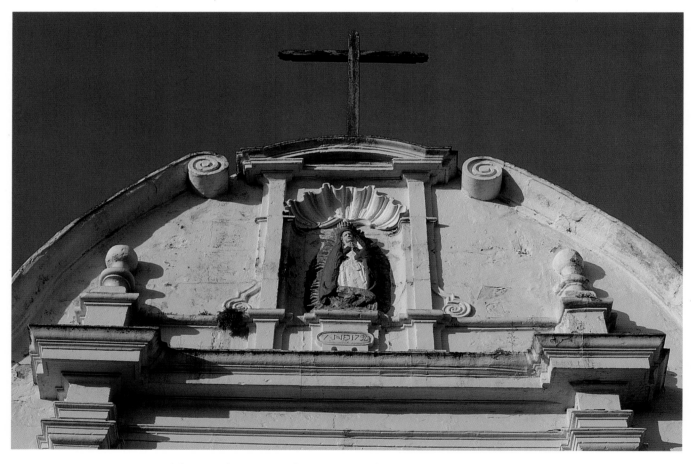

△ The 1794 carving of Our Lady of Guadalupe on San Carlos Cathedral's graceful arch has been declared California's best example of indigenous art by the National Park Service. In 1961, the entire adobe structure was designated a national historic landmark. ▷ The sweet face of Octavia, a descendant of the first sheep brought to California from Mexico in 1776, is one of the attractions at the historic Cooper-Molera Adobe.

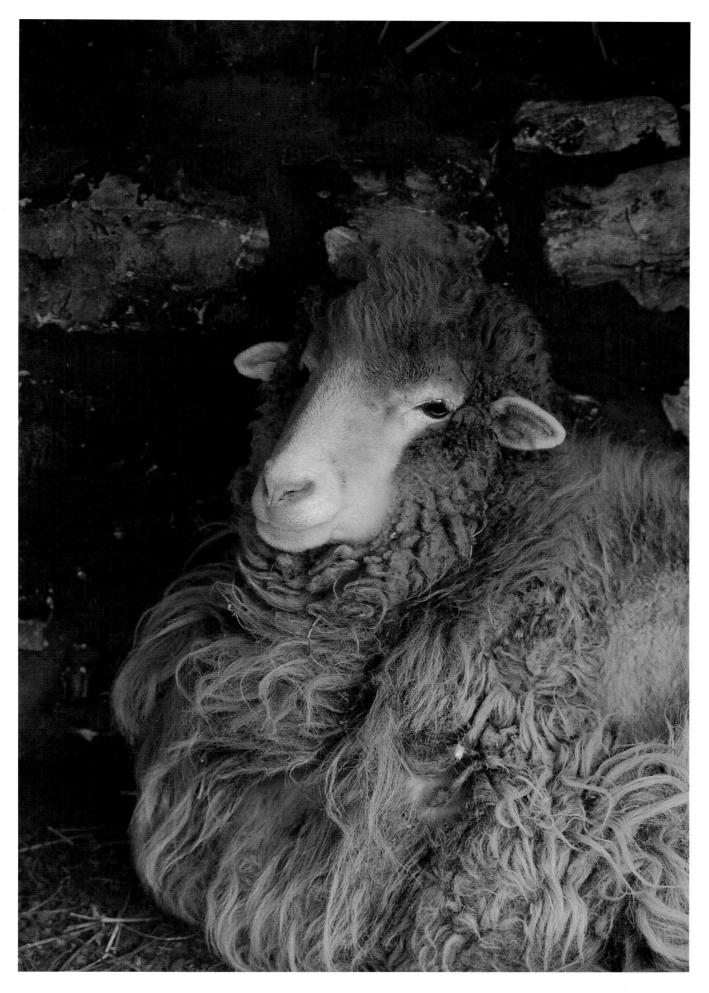

◁ An orange window accents the bright yellow wall of La Ida Café, one of the Cannery Row brothels celebrated in John Steinbeck's novels. Still catering to pleasure, it is now an ice cream stand. △ The same kind of nets that brought in record catches of sardines in the first half of the twentieth century are now used to haul in the squid that sustains the Monterey fishing industry.

△ A colorful nineteenth-century trunk, held together with hand-made nails and latch, is part of the collection at the Robert Louis Stevenson House in Monterey, formerly the hotel where the famous author stayed during a visit to court Fanny Osbourne in 1879.
▷ The sidewalk in front of the Old Whaling Station is made in part from whalebones. In the last half of the nineteenth century, the station was the center of an important industry.

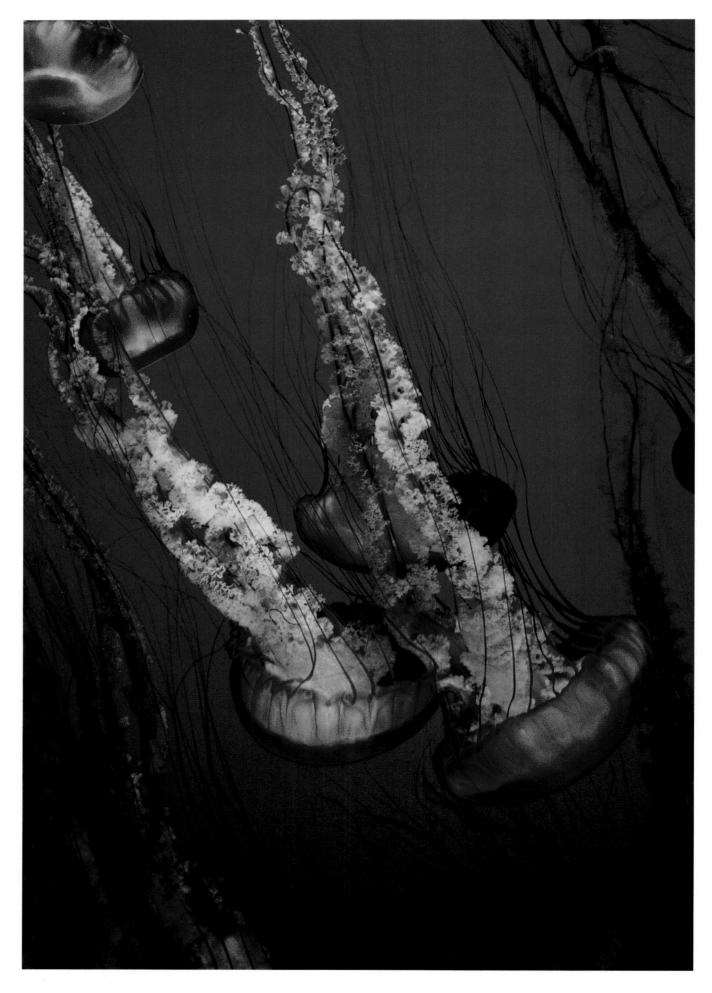

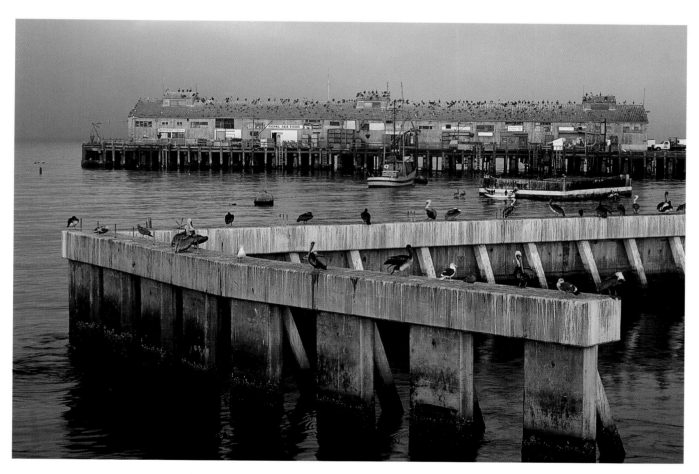

◁ Delicate "jellies" move gracefully in seawater at the Monterey
Bay Aquarium. Their prominence and importance in the ocean only
recently understood, the fascinating creatures are relaxing to watch.
△ Pelicans and gulls line a breakwater and the roof of the fish pack-
ing sheds of Fisherman's Wharf, waiting for the catch of the day.

△ Thick adobe walls and hand-cut timber for doorways, such as these in the Robert Louis Stevenson House, were typical in the architecture of the Spanish and Mexican periods in Monterey. ▷ Weathered tiles in a courtyard of the Monterey Museum of Art's La Mirada extension reflect the city's nautical history.

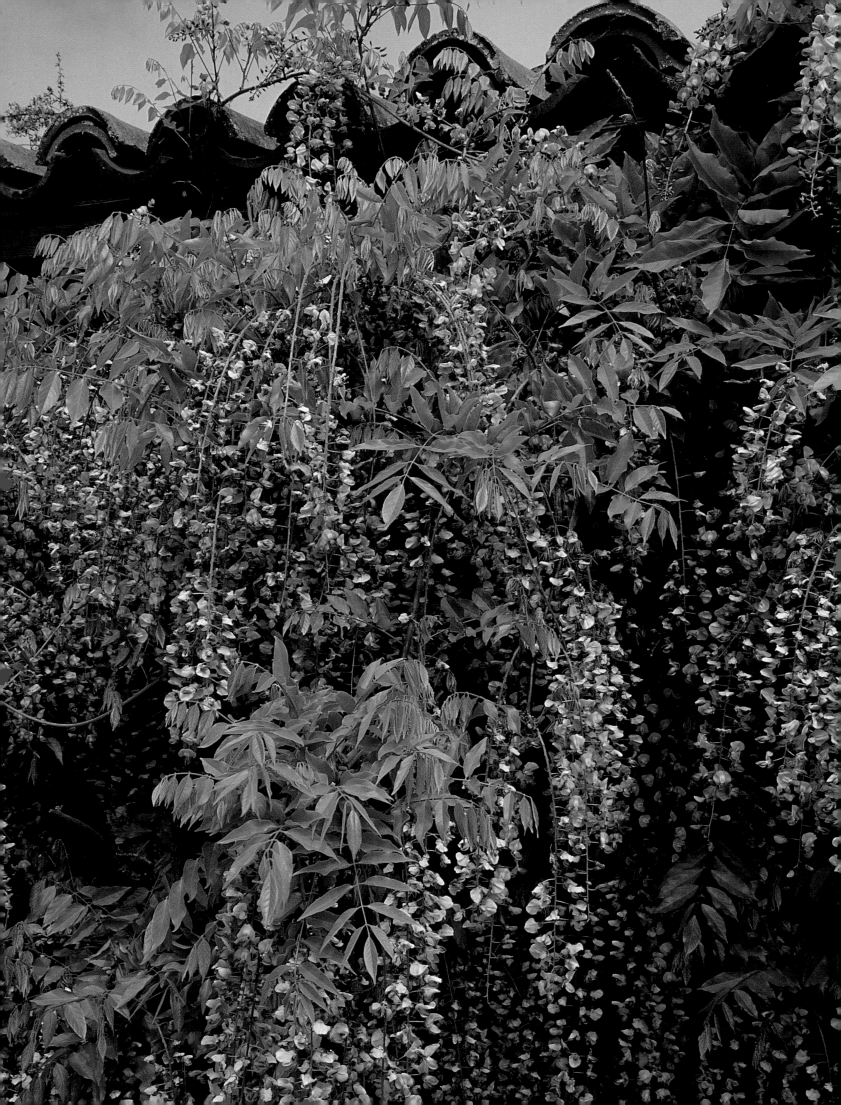

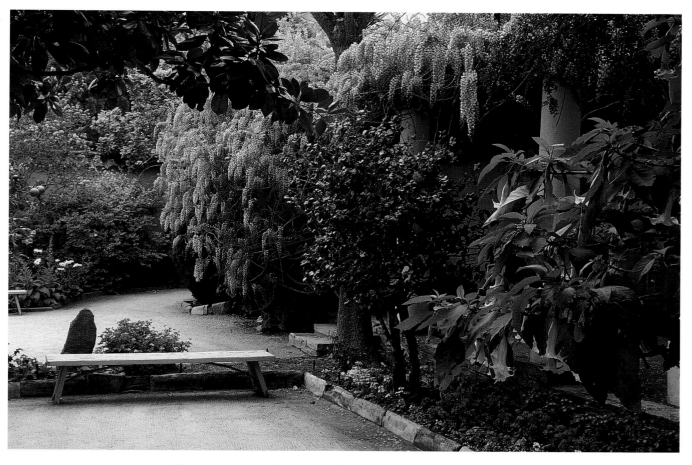

◁ Wisteria cascades down the side of a wall of a Spanish-era house.
△ The Memory Garden in the courtyard of the 1847 adobe Pacific
House, now a state museum, shows the vast, colorful array of plants
and flowers found for eons along the California coast. The garden is
a popular place for weddings, celebrations, and inspirational visits.

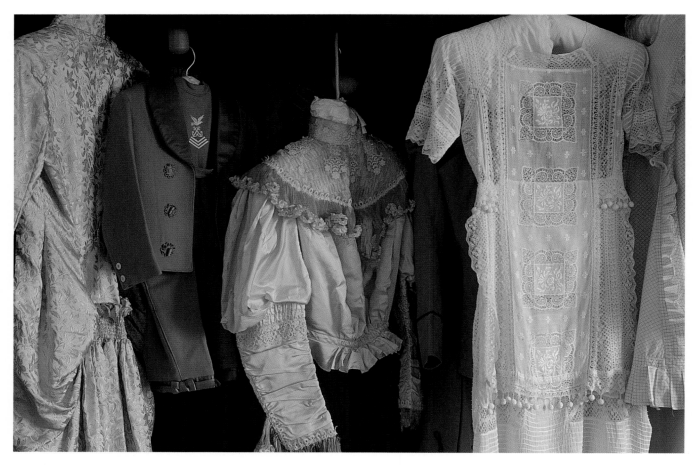

△ Victorian clothes hang in a museum collection to show the styles common during the late nineteenth and early twentieth centuries. ▷ Camellias and ferns line the adobe wall that surrounds the Cooper-Molera Adobe compound. Dotting the property are adobes from the Mexican period and wooden structures, such as the two-story livery in the background, from the early American era.

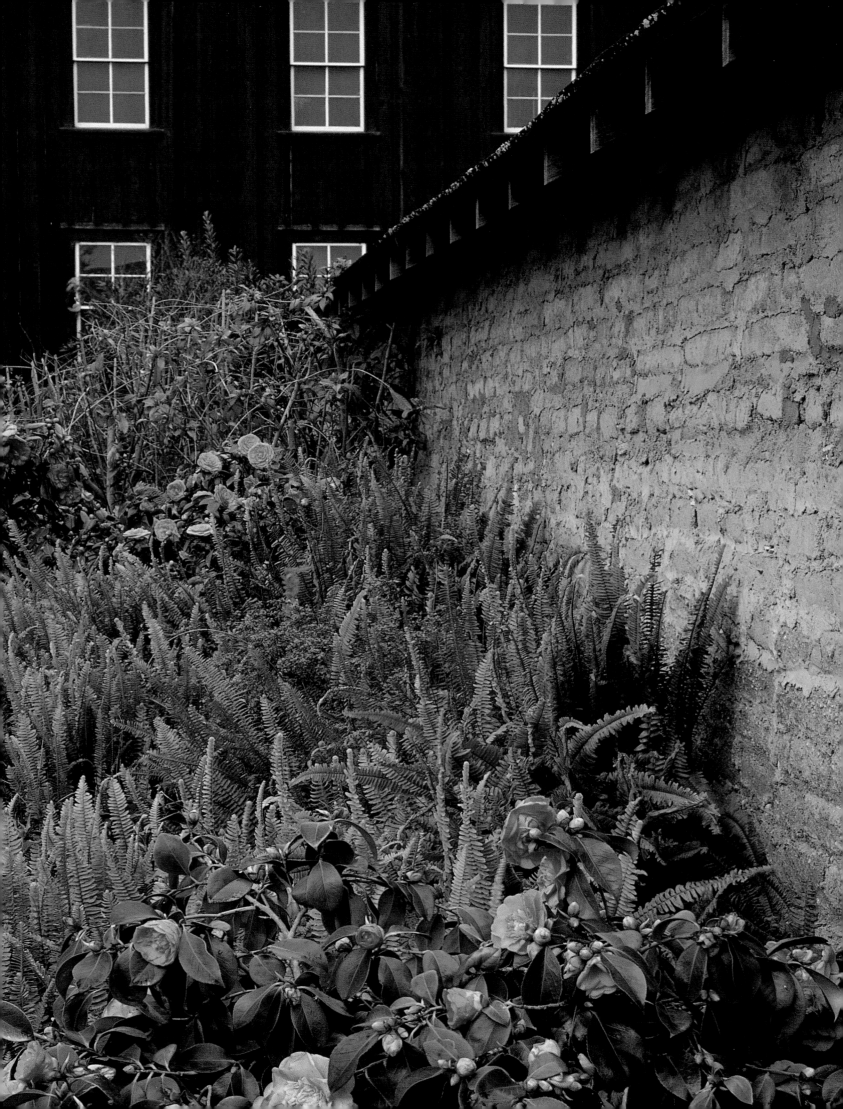

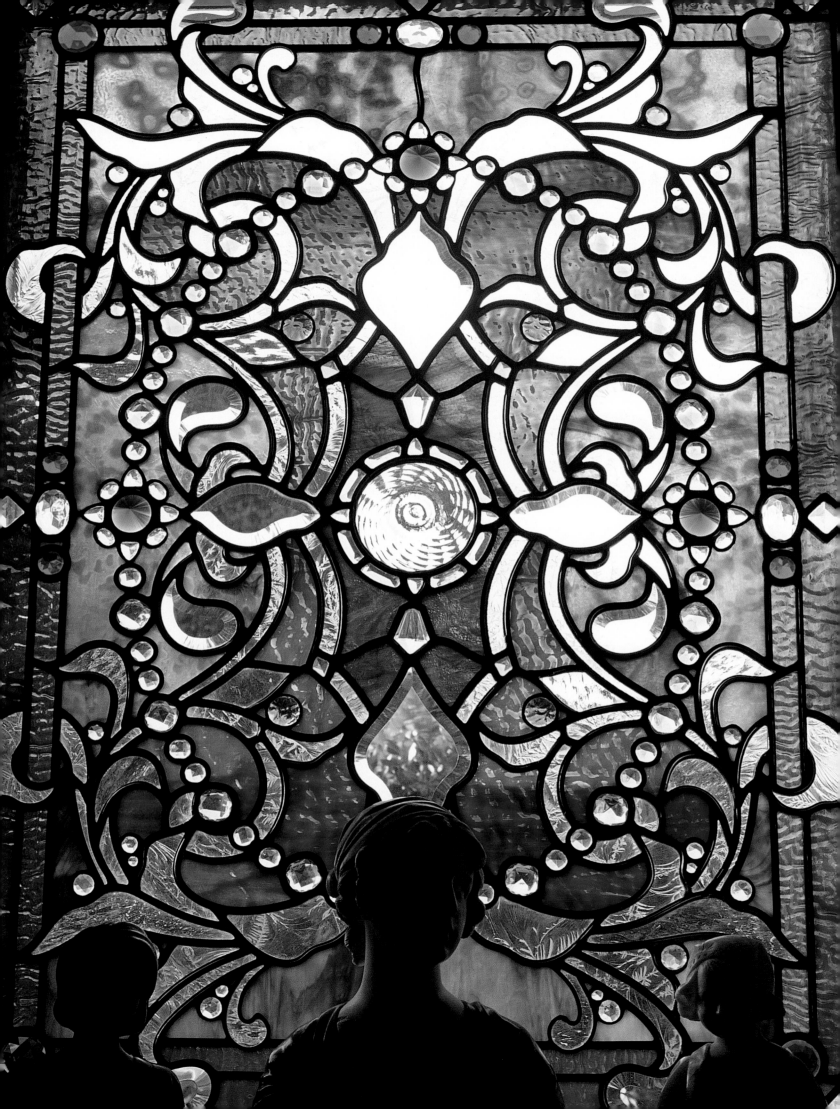

Pacific Grove is the quietest and least noticed of the communities on the Monterey Peninsula. It sits on the northern tip of the peninsula, between bustling Monterey and elegant Pebble Beach, but doesn't receive nearly as much attention as either of them. And that's just the way most of the residents like it.

There seem to be plenty of tourists already staying in the one thousand motel rooms and the dozen quaint bed-and-breakfast inns of Pacific Grove, strolling along the four and a half miles of gorgeous coastline, watching the playful seals and sea otters and occasional whales in the water, following the colorful monarch butterflies that hang out in the winter, looking over the twelve hundred Victorian houses that date back to the nineteenth-century origins of the city, and exploring the local festivals. The Feast of Lanterns each July packs ten thousand people onto a small beach at Lovers Point to watch a pageant that hasn't changed for nearly a century.

This community isn't only a haven for summer tourists. PG, as it's known locally, is prized for its livability. It is actually a modest town that treasures its environment, its architecture, its small-town traditions, and its public schools. A high school football game on Friday night is apt to get a bigger crowd than a first-run movie opening. The alumnus selling popcorn at the game could well be a county judge, a police chief, or a seamstress.

PG unabashedly calls itself "The Last Hometown."

Here is a self-contained community where things are convenient for the seventeen thousand residents. There are a dozen churches of various faiths, a range of grocery stores, three hardware stores, doctors' offices, gas stations, banks, lunch counters, ball fields, beaches, and schools that produce athletic, academic, and musical teams. All of this adds

up to a livable community, which attracts families fleeing suburban sprawl and modern isolation.

Many residents surf, going into the ocean at the end of their streets. Many golf, playing on the city-owned course, which maintains the lowest greens fees of the twenty golf courses on the Monterey Peninsula. Most of the residents are walkers who stroll along the shoreline with the tourists, take the trails through the more remote pine forests that the city owns, or just amble along the old streets with their Victorian charm.

PG is a delight for nature lovers, with birds of many feathers flocking through the area at various times, marine life providing shows every day, deer roaming along the streets and through yards, and raccoons taking over as the masked bandits of the night.

Most of the time, life in PG is scored by the thundering sound of the ocean surf smashing into the rocky coastline, then rolling back and hitting it again. The uninitiated might mistake the noise for the roar of a freeway, a passing truck, or even a distant freight train. But a close listen reveals the primordial sound of a heartbeat—*coooshhhh, coooshhhh, coooshhhh.*

When the ocean is quiet, the chimes of City Hall serenade the town, ringing out every fifteen minutes to mark the passing day. The chimes sound only in daylight hours, of course, so as not to disturb anyone's rest. At Christmastime, the carillon in the old bell tower plays familiar carols every fifteen minutes to cheerfully remind everyone of the season.

In the spring, residents fan out to collect samples of the more than six hundred varieties of wildflowers that grow in the area. They put them in spare vases and old peanut butter jars and display them in the annual wildflower show at the city-owned Museum of Natural History.

It's a toss-up to decide which is more intriguing—the amazing display of wildflowers or the annual quilt show, where local quilters hang their best work on the walls of the city-owned Chautauqua Hall, a meeting house built in 1881

◁ *A leaded stained-glass window with statuary in the lobby of the Seven Gables Inn in Pacific Grove makes this 1886 Victorian as much a museum as a popular bed-and-breakfast inn.*

39

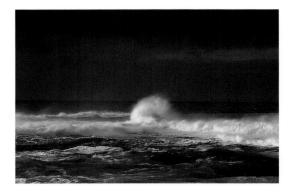

that is now used for exhibits, Boy Scout meetings, exercise classes, and dances.

But the real measure of small-town life might be better explained by the fact that Pacific Grove doesn't have any traffic lights on its city streets. Drivers use stop signs, yield signs, and old-fashioned courtesy when moving around in town.

For sheer charm, the most notable single event in PG is undoubtedly the annual Butterfly Parade. Elementary school children make butterfly costumes in their classrooms, sometimes ornate, sometimes simple, sometimes only marginally related to butterflies. And then on the second Saturday in October they parade through the streets, following the high-school band and motorcycle cops with butterfly wings attached to their backs, to welcome back the fluttery, orange-and-black monarchs that migrate to Pacific Grove for the winter. Some of the children walk with their pets, costumed or otherwise, and the curbs are lined by whooping parents with cameras whirring.

Beyond the absolute charm and cuteness of the children's parade, though, PG residents have put their pocketbooks where their hearts are to help protect the butterflies, the only insect in the world known to migrate with the seasons. The monarchs that winter in PG come from colder places in the north and east, some flying as far as two thousand miles to visit the milder climate. A few years ago, when a housing subdivision threatened to encroach on one of the two groves of tall trees that the butterflies like, PG residents went to the polls and voted a special tax on themselves to buy the property and preserve it for the monarchs. Now called the Monarch Grove Sanctuary, volunteers stand by when the butterflies are there in order to explain it all to anyone who visits.

Such sharing is appropriate for a city that was actually started as a church retreat in the woods. The Methodist church in San Francisco was given a chunk of forest in 1875 by the local development arm of the Southern Pacific Railroad and started a summer camp for the faithful. Tents were pitched at Lovers Point at first. Soon, fifty-dollar lots were sold and wooden platforms were built for the tents. Then boards were put around them to transform the tents into small houses. And people started staying year-round. Many of the small, tent-sized houses still remain, but only a few have swatches of the canvas that originally defined the shape and size of the homes.

With the exception of the city-owned Point Pinos Lighthouse, an 1855 structure said to be the oldest continuously operating lighthouse on the West Coast, Chautauqua Hall is believed to be the oldest building in PG. It was built just six years after the Methodists arrived in the woods. But a flurry of construction in the 1880s resulted in several buildings that remain standing, including the Spartan 1889 Centrella Hotel that still operates as a hotel across Central Avenue from Chautauqua Hall; the 1885 Little Red House next to the Post Office on Lighthouse Avenue that's now a café and garden shop; the spectacular 1886 Seven Gables Inn that's a celebrated bed-and-breakfast overlooking Lovers Point; and the 1887 St. Mary's Episcopal Church on Central, still one of the busiest churches in town.

The old frame structures, with their Queen Anne turrets and Victorian gingerbread, have been complemented by other treasured architecture in later years. The gracious, adobe-style city library was built across from the museum in 1911 with money from industrialist Andrew Carnegie. The Asilomar Conference Center, now a state-owned facility with four hundred rental rooms next to the ocean, was built from stone and redwood in 1913 as a YWCA camp. And the old Holman's Department Store, at five stories the tallest building in PG's downtown, was built in 1926 as a state-of-the-art retail center.

Living with the old buildings is every bit as comforting as just visiting them. They provide an idyllic, hometown feeling, whether Pacific Grove is actually the last such town or not. This city so proud of its heritage makes sure—through building codes, occasional elections, and four levels of city review—that even new structures are designed to look old.

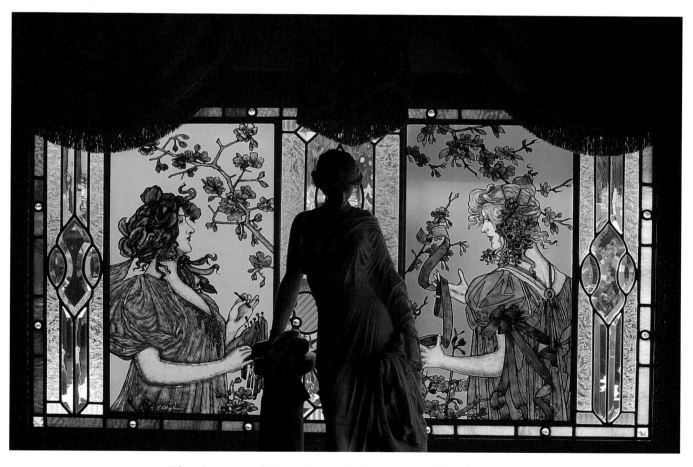

△ The elegance of Victorian art is demonstrated in this spectacular window depicting ladies in a garden framed by rich velvet drapes, along with an eye-catching statue in the sitting room of the Grand View Inn at Pacific Grove's Lovers Point.

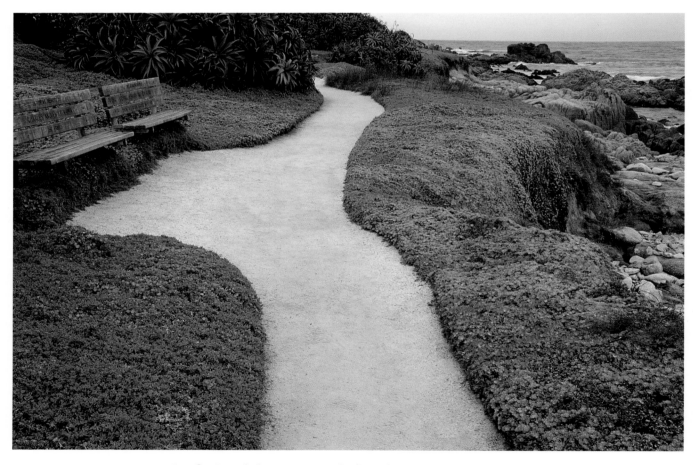

△ Pacific Grove's "Magic Carpet" of ice plants along the rocky coast-
line blooms brilliantly from winter into summer. It's divided by
a popular trail that carries walkers and runners, and invites lovers
of all sorts to benches overlooking a cove that attracts harbor seals.
▷ The functional simplicity of Victorian design doesn't have to be
bland, as the colorful back of this house demonstrates.

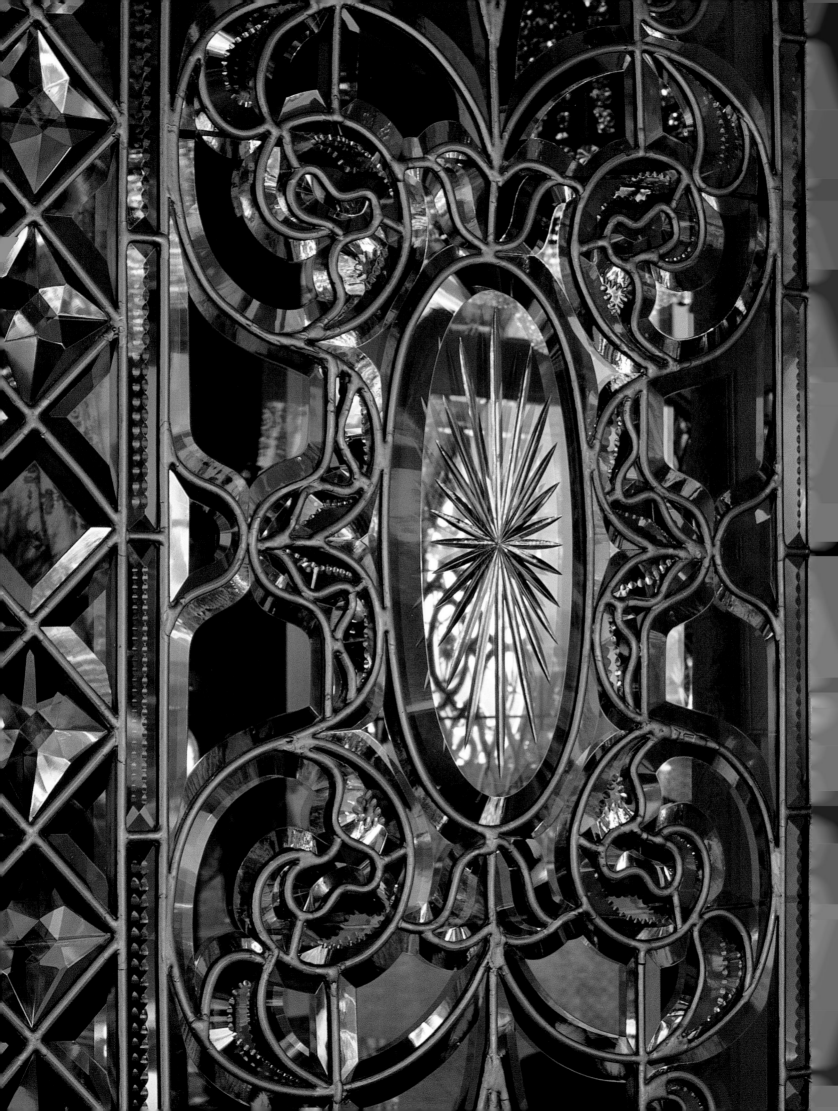

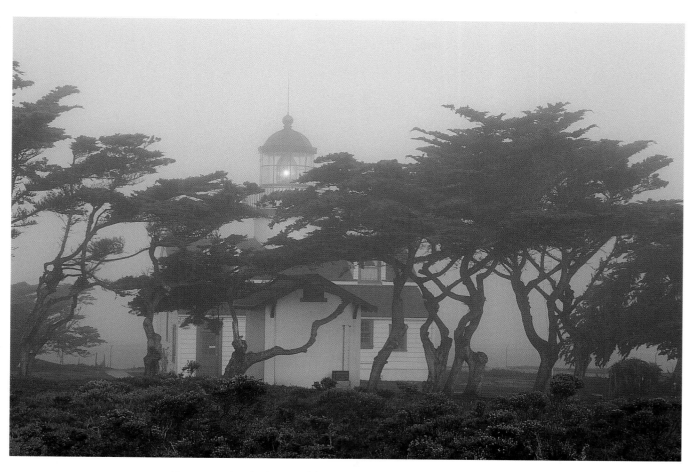

◁ Ornate stained-glass and lead designs typify Victorian windows.
△ The fog that shrouds cypress trees on the Monterey Bay shoreline illustrates the need for this Point Pinos Lighthouse, the West Coast's oldest continuously operating lighthouse. Its beacon has been cutting through the fog and the dark of night since 1855.

△ Cats, chickens, giraffes, and snakes were overlooked in the
Victorian decorations of early Pacific Grove. But time marches on.
▷ In this typical board-and-batten house near Lovers Point, plants
dress up some of the utilitarian lines of Victorian architecture.

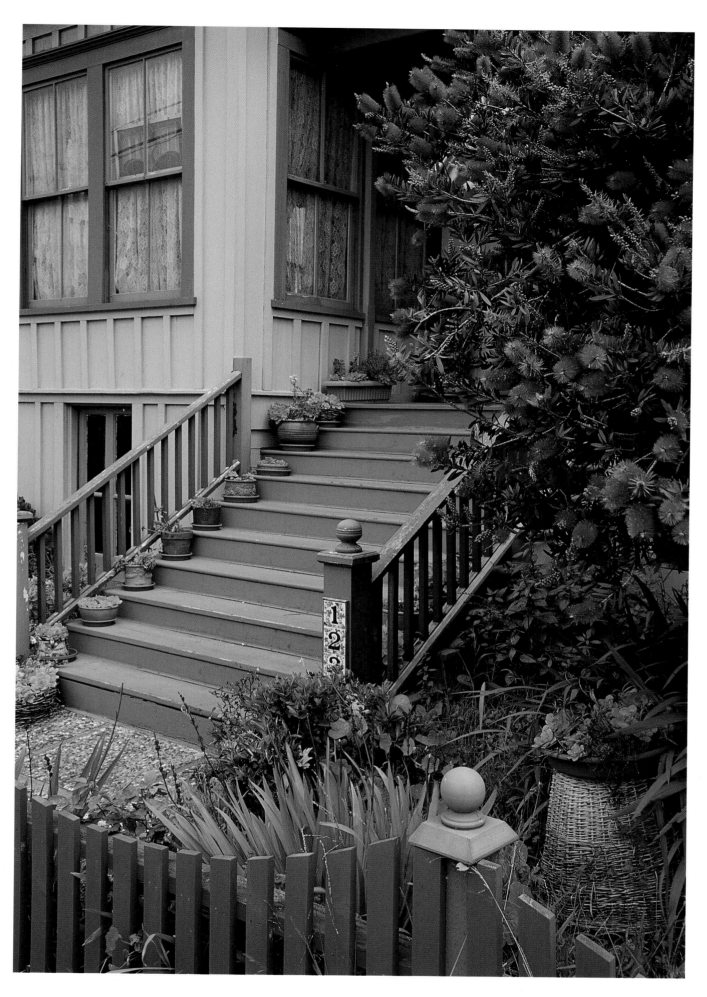

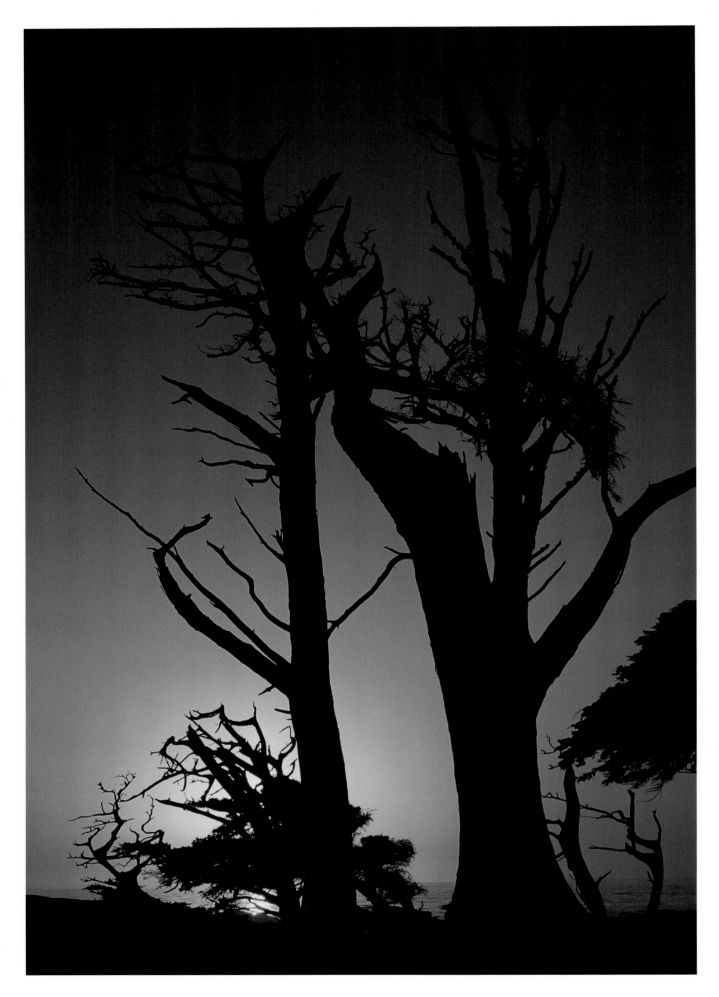

It is golf that brings the big tournaments and network television attention to Pebble Beach, making it world famous as a sports capital and a stunningly beautiful seaside resort.

Before golf, Pebble Beach was little more than a hunting lodge in the forest and a network of horse trails for the guests of a posh Monterey hotel.

Golf found Pebble Beach—and its treasured Del Monte Forest—in 1919, after developer Samuel F. B. Morse wisely decided that a luxurious golf community made more sense than additional subdivisions of small houses like those being built in neighboring Pacific Grove and Carmel. He sold large, estate-sized lots along a planned golf course to raise money for development, and then charged admission to the private roads to pay for maintenance.

The Pebble Beach Golf Links was joined by two private golf courses in the 1920s—the Monterey Peninsula Country Club's Dunes Course and the Cypress Point Club's course. Two more were added in the 1960s—the country club's Shore Course and the Pebble Beach Company's Spyglass Hill Golf Course—and another two in the 1980s—the Company's Spanish Bay Golf Links and the Northern California Golf Association's Poppy Hills Golf Course.

The seven full-sized, eighteen-hole golf courses in Pebble Beach now spread along nine miles of Pacific Coast and through the forest of tall pines, redwoods, cypress trees, and oaks. Four courses are available for public play—three at several hundred dollars per person per round; three private courses are reserved for club members and their guests.

Together they occupy 1,220 acres, a full fourth of the eight-square-mile Pebble Beach community, which dominates the actual granite outcrop of the Monterey Peninsula, the westernmost part that juts out into the Pacific Ocean.

In addition to the golf—or as part of it—there is general luxury in the forested community. There are two elegant hotels—The Lodge at Pebble Beach (built in 1915) and the Inn at Spanish Bay (built in 1988)—that have housed American presidents, European royalty, show business stars, and business czars since they were first opened. They are complete with the mouth-watering cuisine of fine restaurants that fly in food to make sure it is fresh enough, and bars where you might see celebrities sitting on stools next to out-of-work mechanics, talking over the topics of the day.

There are also festivals and competitions apart from golf that attract star-studded crowds to Pebble Beach at regular intervals. For instance, the Concours d'Elegance, which for a Sunday in each August takes over the famous eighteenth hole behind The Lodge, has attracted the finest and rarest collector's cars from around the world for more than fifty years. It caps a long weekend of vintage car shows, road rallies, races, and auctions where cars sell for millions of dollars.

And, of course, there are a couple of hundred mansions on the coastal bluffs and in the forest clearings of Pebble Beach, and a couple of thousand other houses that would hardly be considered pedestrian.

Pescadero Point is a wonderful spot on its own, sloping down to the water. But it also offers a look at a unique house in Pebble Beach—a Byzantine castle built from Italian marble in the late 1920s. It was a railroad baron's showplace, with marble columns and extensive mosaics throughout the ten-thousand-square-foot structure, seven bedroom suites, bathrooms with gold plumbing, and servants' quarters. The castle, perched on a bluff a hundred feet above the Pacific Ocean, was recently on the market for $25 million.

Although this was the highest price asked to date for a Pebble Beach estate, the castle next to Pescadero Point isn't the only building where price has been no object. There are several sprinkled around, some as pretty as the old Spanish colonial villas that date back to the early twentieth century. Morse had originally required Spanish colonial or Mediterranean styling to set a tone for this exclusive community.

◁ *The unique cypress trees of the Monterey Bay shoreline, some showing advanced age and wear, stand bold against the brilliant orange and yellow of a sunset at Pebble Beach's Cypress Point.*

Even today, Pebble Beach is accessible only through five gates staffed by guards who screen the traffic and collect admission fees from people who don't have houses, jobs, or reservations inside.

All of those gates lead to the 17-Mile Drive, the scenic route completed in 1915 to link the Hotel Del Monte in Monterey with the new Lodge at Pebble Beach. It originally stretched through Monterey, Pacific Grove, Pebble Beach, and Carmel. These days it's really only about ten miles long, the most famous part of a private road system that now has about seventy-five miles of pavement and one hundred miles of unpaved trails for horses, bicyclists, runners, and walkers.

Although the road is shorter and the forest is smaller, the coastline is still as spectacular as it always was, the views are still unimaginably beautiful, the wildlife enchanting, and the flowers gorgeous. Superlatives are easy to come by when you drive—or ride a horse or bike, walk, or run—along 17-Mile Drive. There's the churning, crashing surf of the ocean spraying salty mist across the shoreline. There are the golf courses with their close-cut green grass, sandy traps, and deer munching on everything in sight. And there are the forests of tall trees all around you, all shapes, all shades of green, lining the hillsides and slopes of the coast.

This is some of the most beautiful shoreline in the world. Rocky outcroppings and cliffs support wind-swept cypress trees that grow lopsided from them. Waves splash around offshore rocks covered by napping seals and seabirds, then crash on pure, white beaches. Sea lions bark over the roar of the surf. Pelicans glide gracefully overhead. Passing whales occasionally surface nearby. Schools of dolphins sometimes swim by, jumping through the water like groups of school kids skipping on a playground.

The awesome view from 17-Mile Drive has been enjoyed by millions of people over the years, those lucky enough to feel the cold ocean mist hit their faces as well as those who have seen the deep blue ocean, the dark green golf courses, and the towering forests only in pictures.

The Lone Cypress, and the inspirational view around this gnarled old tree, is the most photographed and celebrated point on the famous drive. The tree is the copyrighted trademark of the Pebble Beach Company, which owns the famous resort property, and part of the official emblems for Monterey County and several nearby cities. Physically, the tree is about six miles from the Pacific Grove side, three miles from the Carmel side, and about midway between Cypress Point, the westernmost point of Pebble Beach, and Pescadero Point, which is the northern tip of Carmel Bay.

The Lone Cypress is magical, growing from a rock for an estimated 250 years. It sits by itself, looking across the churning ocean to Point Lobos and, on a clear day, Big Sur stretching out for miles beyond.

There are other points and stops along 17-Mile Drive that are equally worthwhile:

Point Joe reveals the most active ocean along the drive, a whipping, splashy, foamy surface controlled by the shapes of the floor below it.

Bird Rock, which is about the midway point of 17-Mile Drive, looks unusual because its granite gray bottom is capped by a top of pure white, evidence of the cormorants that nest there and have colored it with years of their droppings.

Cypress Point and Fanshell Beach are closed in winter months, when harbor seals take over the beaches to have their pups and nurse them until they're ready to swim and feed themselves. In the months when those sites are open, they can put you so far into ocean breezes you'll feel like a mariner.

If anyone but Morse had bought it in 1919, Pebble Beach might today be a Honolulu of the West Coast, obscured by high rises, shopping malls, parking lots, and carnival attractions. Peaceful Stillwater Cove—so remote it's been a landing site for booze, drugs, and illegal immigrants—might have been lost to theme parks and fast-food neon.

▷ *Hood ornaments illustrate the detail of the world's most beautiful cars, stars of the annual Pebble Beach Concourse d'Elegance.*

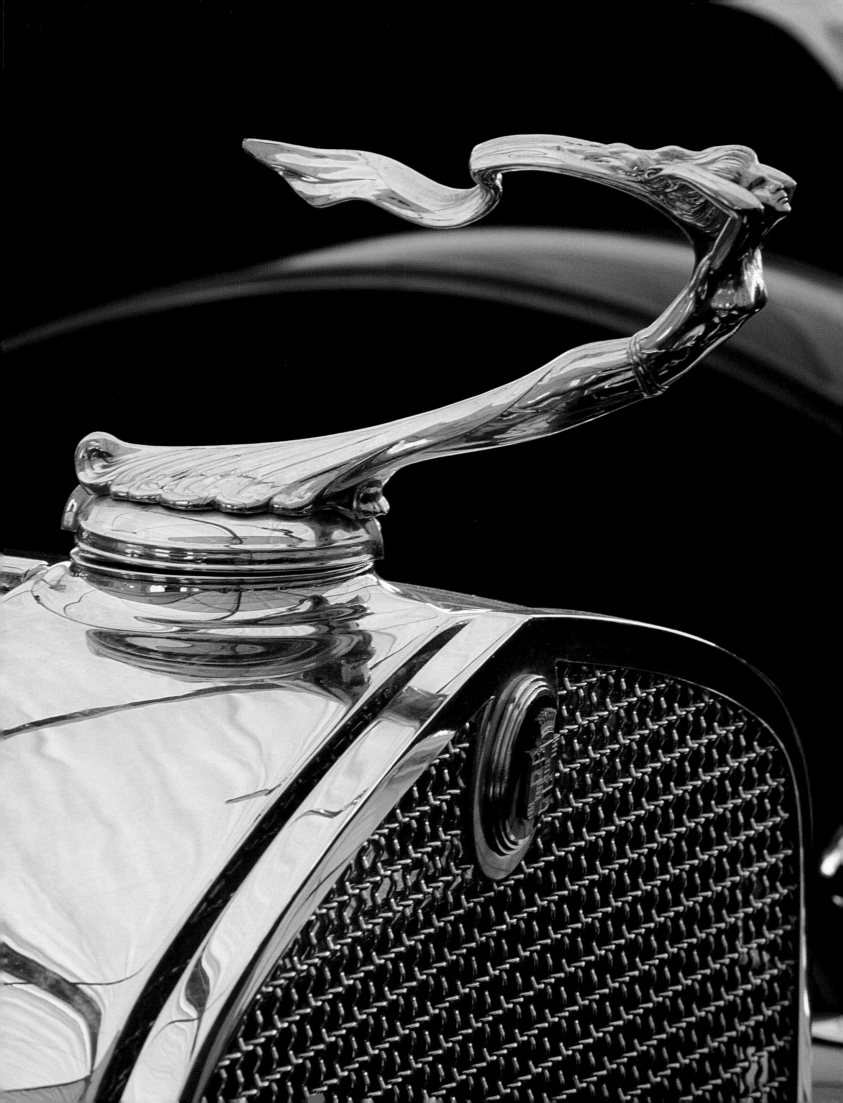

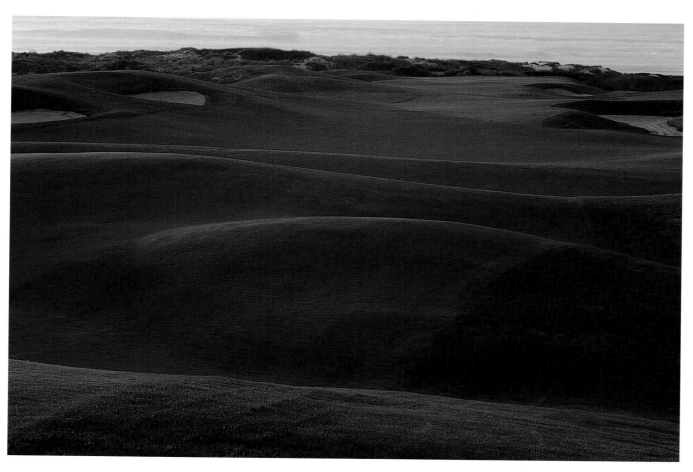

◁ Old-world craftsmanship is evident in this front door of Casa Palmero, a luxurious spa next to The Lodge at Pebble Beach. △ Rolling over sand dunes to the sea, the manicured grounds surrounding the fourteenth hole of the Spanish Bay Golf Links show the artistry of golf champion and course co-designer Tom Watson.

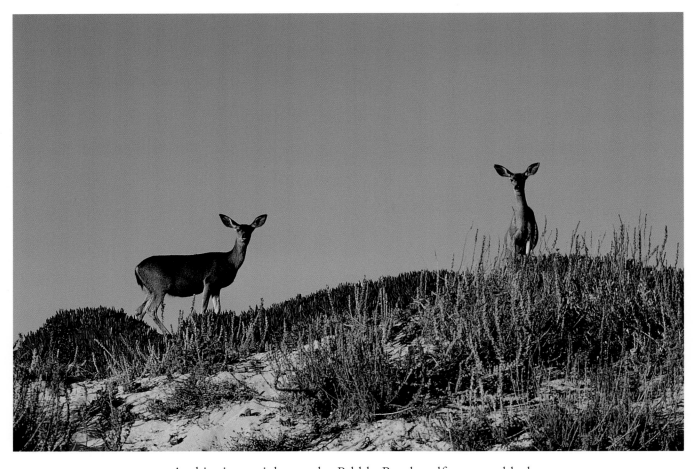

△ A ubiquitous sight on the Pebble Beach golf courses, black-tailed deer munch on grass and shrubs as they watch the golfers. ▷ Blooms of the sticky monkey-flower, native to the area, decorate poison oak, another native that is commonly found on the floor of the Del Monte Forest in Pebble Beach.

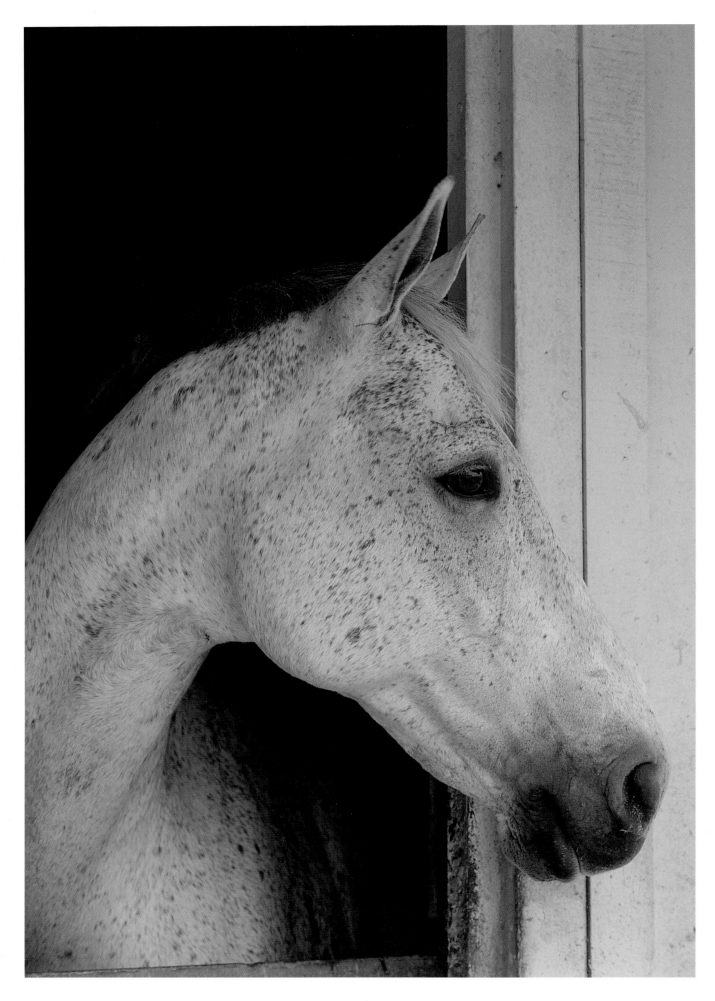

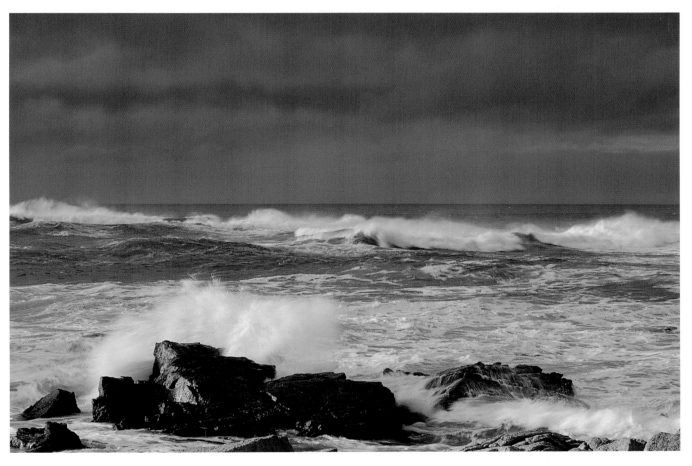

◁ A handsome Arabian looks out from his stall at the Pebble Beach Equestrian Center, which has hosted many West Coast horse shows and events. Bridle trails wind for thirty miles through Del Monte Forest and along the beach, making pleasure riding an everyday attraction for those who board their horses here. △ Harbinger of an approaching storm, a gray sky looms over the blustery, churning sea at Spanish Bay.

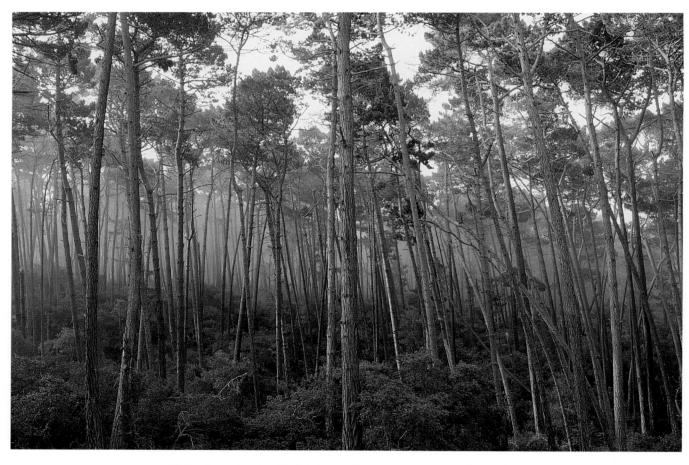

△ Tall pines in the Del Monte Forest appear fragile at dawn.
▷ A cypress grove in the forest provides the form that genera-
tions of artists have struggled to capture on canvas. Scattered
along the Pebble Beach coastline, no two groves look alike.

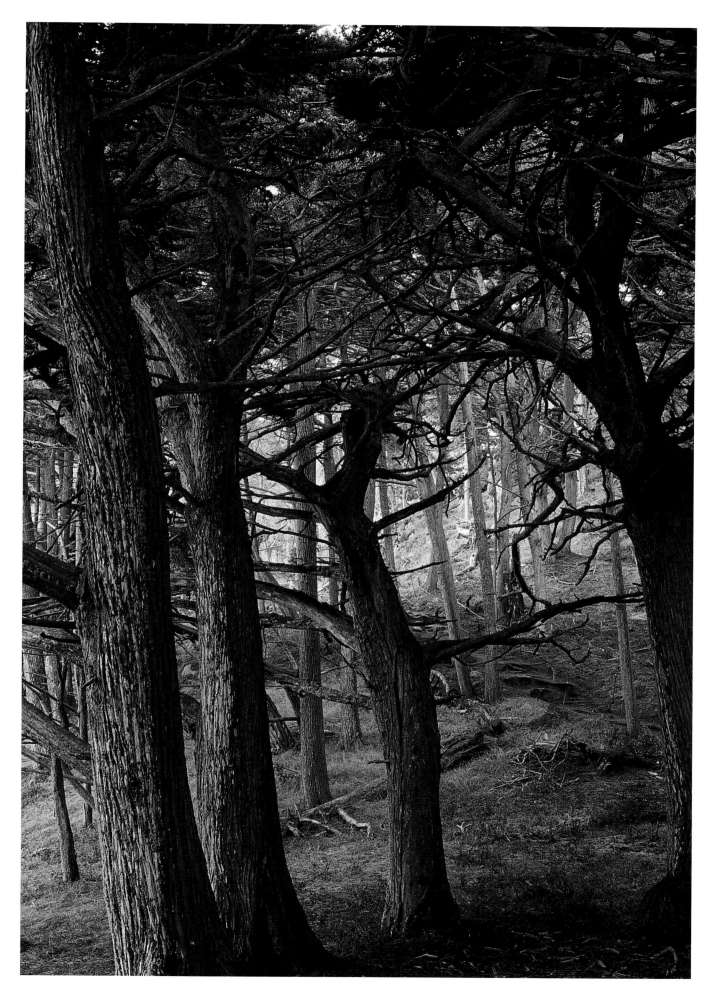

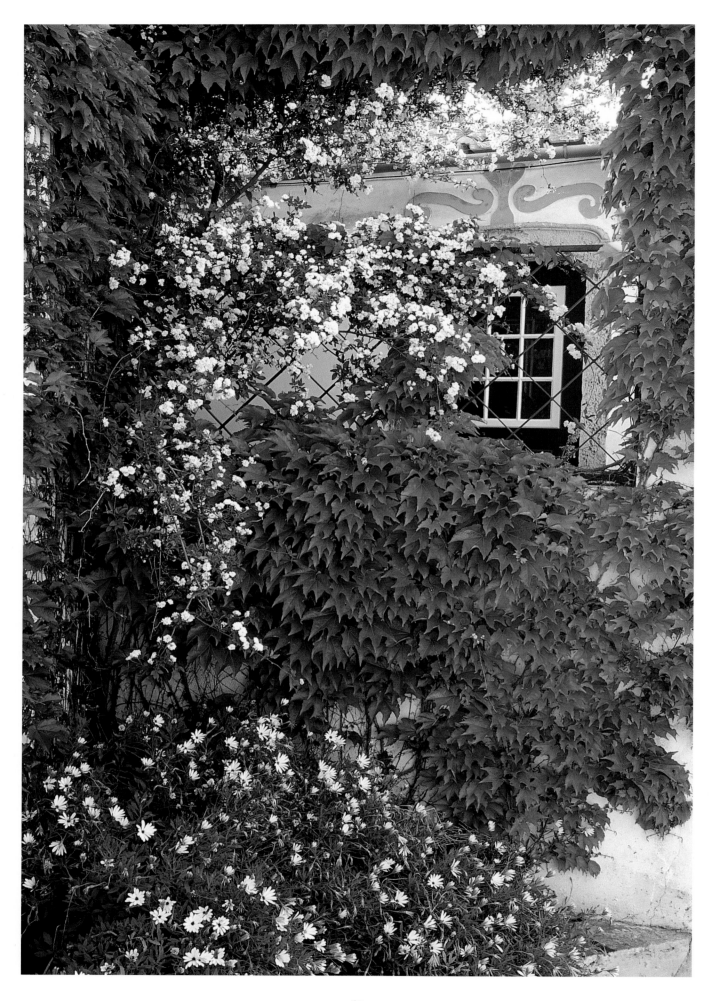

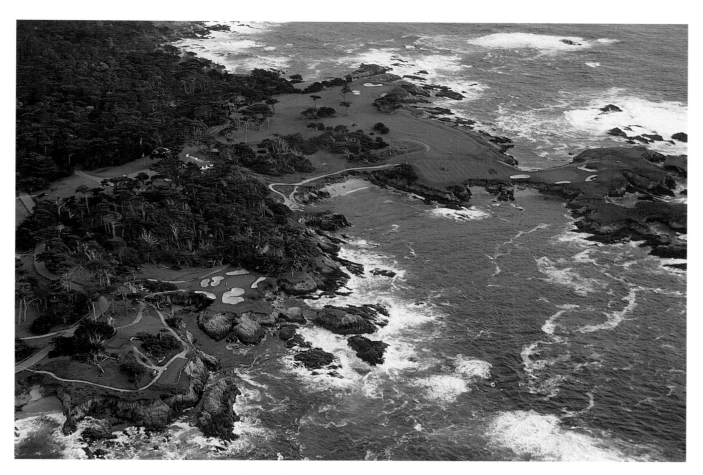

◁ Flowers and vines drape a mansion in Pebble Beach, allowing a glimpse of a picturesque window and delicate flourishes on the wall. △ This aerial photo shows four holes—the fifteenth through the eighteenth—at the exclusive Cypress Point Club's golf course, a private course that was designed around the marvelous bends of the shoreline at Pebble Beach.

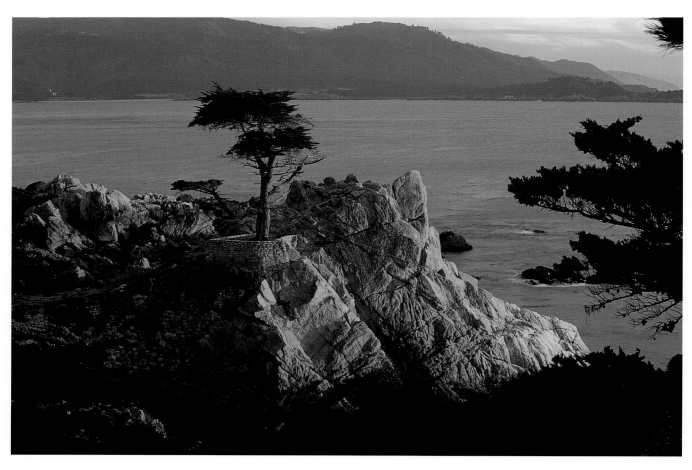

△ The Lone Cypress, the symbol of Monterey County and a registered trademark of the Pebble Beach Company, stands out at any time, but it is particularly stunning as the sun sets. The tree seems to grow right out of solid rock alongside 17-Mile Drive. The craggy coast of Point Lobos sits across Carmel Bay.
▷ An aging iron gate through a stone wall opens onto a charming estate designed by famed architect Charles Greene. The gate sits at the end of a path that is well hidden by trees.

Carmel is best in spring, after winter storms end and before summer tourists take over the streets. Or maybe it's best in fall, after summer tourists are gone and before winter storms begin. But then, winter can be cozy. And summer can be fun. So maybe Carmel is really best whenever you can be there.

It does attract a couple of million people each year; about four thousand are lucky enough to live there year-round.

There are all sorts of reasons for the popularity and world-wide fame of this resort. There's always curiosity, the prestige factor, the name-dropping, to explain some of it. There's always the search for celebrities in the place where a famous actor was once mayor, a well-known football figure sometimes sits in front of a local market drinking soda, and a rock music idol visits his former wife and takes their children to the beach.

And there's always the draw of quaint inns and lodges, fine restaurants, and colorful shops that create a browser's heaven.

But the most enduring thing about Carmel, the thing that has attracted residents and crowds for a century, the thing that generally underlines all of life there is simply the setting.

Carmel nestles in a hillside of the Santa Lucia Mountains, a beautiful hillside sloping down to the crescent of Carmel Bay. Towering trees on the hill and the white foam of surf at the bottom seem to cuddle the village, making it as romantic as the cottages that peek out from behind the pines and oaks. Carmel is often described as quaint, charming, peaceful, and picturesque, but the word that really catches it best is "cozy."

From the top of the hill, or from a flight overhead, you see more treetops than roofs, with that gorgeous blue bay on the horizon, and a rocky coastline stretching to the north and south. It can be breathtaking.

At a closer look, there are narrow streets without sidewalks or curbs, winding around trees that are so prized they are numbered. Cottages and distinctive houses sit close together,

◁ *A colorful garden is accented with a low stone wall topped by an old Indian grinding stone.*

all individually built, most from wood or stone, two-thirds of them constructed and occupied before World War II.

In the shopping area there are streets that look like French villages, English or German neighborhoods, Spanish plazas. Some structures were designed by immigrants from those lands. Some were inspired by travels abroad. And some were simply adapted from movie sets. This mix of styles in an inspirational setting has made Carmel so popular that prices for available property have risen sky-high, and are a major topic of conversation. There may still be a few crumbling shacks left in the city, remnants of cottages built in the early twentieth century with one-inch thick planks held together by narrow battens. Yet these "shacks" sell for hundreds of thousands of dollars, if they become available. For a larger place near the water, with a few extra bedrooms and extra baths, just start adding zeroes to the price.

The prices only add to Carmel's mystique, the mystique that makes mail-order businesses and such want to have Carmel addresses, even if it's just a postal box in an outlying area.

In fact, the name "Carmel"—a name given to the nearby river, then the bay, by the Carmelite priests who came in 1602 with Sebastian Vizcaino—has became so popular that it's been adopted by much of the development around the one-square-mile city on the hillside. There are Carmel Woods, Carmel Meadows, Carmel Knolls, Carmel Highlands.

The irony in all of this is that the original development of Carmel failed. As unlikely as it now seems, the first developer who mapped building lots and started putting up houses in the forest scrapped the effort after a couple years, unable to attract many buyers. Around 1888, a Monterey real estate salesman named Santiago Duckworth acted on a rumor. He had heard that the Southern Pacific Railroad was going to extend its line from Monterey to Pacific Grove, which was becoming a bustling Methodist retreat, and then on to the Carmel Mission the Spanish priests had built on Carmel Bay in 1771. Duckworth bought land along the anticipated rail line, built a cottage for himself—a single-walled, board-and-batten

structure—marked off two hundred lots around it, and started pitching his vision of "Carmel City," a summer retreat for Catholics.

But the railroad stopped in Pacific Grove, Catholics didn't rush into the remote forest, and Duckworth gave up his plans in 1890, leaving behind little more than his cottage, which still stands on Carpenter Street near Second Avenue.

A second developer came along just after the turn of the century, filed a subdivision map in 1902, and started building the city that is officially named Carmel-by-the-Sea. The early advertising pitched it to schoolteachers "and other brain workers" as a retreat from big-city living.

The development attracted a few college professors and artists who built modest houses among the trees and natural landscapes, incorporating local woods and stones.

Development was slow until the 1906 San Francisco earthquake sent homeless artists fleeing from the destruction. One hundred miles south, they found cheap land, a natural setting, and safety. As a result, the village of Carmel became an artists' colony that produced works of art, legends, and traditions that have endured through the decades.

A list of writers who have lived in Carmel over the years is like a walk through a library: Sinclair Lewis, Jack London, Upton Sinclair, Booth Tarkington, Mary Austin, Lincoln Steffens, Ernest Hemingway, Gertrude Stein, Alice B. Toklas, and the poets Robinson Jeffers and George Sterling.

Early on, Carmel was a Bohemian paradise, where writers and artists insisted on quiet morning hours to create—or to recover from hangovers. Then they socialized into the night, gathering on the sandy beach to pluck abalone off the rocks and roast it over driftwood fires. They talked over the issues of the day, drank, and sang songs they made up, like this one:

O some folks boast of quail and toast
Because they think it's tony.
But I'm content to owe my rent
And live on abalone.

It was a colorful way of life. The creative residents helped ensure that the city kept its unique houses and crooked, tree-lined streets with no sidewalks or night lighting.

In 1916, residents, worried by the prospect of businesses moving into the village, incorporated as a city in order to institute a law that bans cutting trees. There are some fifty thousand trees now, ranging from tall pines and redwoods to wind-sculpted cypress trees that line the bluff above the beach, and coast live oaks that spread out like shrubs.

Later laws kept development off the beach, limited building heights, banned electric signs and jukeboxes, and limited the number of restaurants in the village to sixty. Local laws prohibited numbering the houses, thus preventing mail delivery and forcing residents to go to the post office to get their mail. So the post office has become a community center where news is exchanged, petitions are signed, and political careers are started—or stopped. When California legislators in the 1950s considered requiring all houses to have numbers, Carmel threatened to secede from the state.

A look around Carmel today usually evokes smiles and questions about the fairy-tale houses with roofs that dip and curve, windows in various shapes, and other whimsical features throughout. These houses started appearing in 1924, when a builder named Hugh Comstock constructed a home for his wife, Mayotta Brown, to display the Raggedy Ann dolls she made and sold. The house received such attention that others hired Comstock to build dollhouses for them. The most noticed of his fairy-tale structures is the Tuck Box Tea Room downtown, on Dolores Street between Ocean and Seventh Avenues.

The city has only recently allowed builders to utilize concrete and fake stone. This change is the result of a push for bigger houses in a village that is as popular today for its proximity to golf courses as it is for its white sand beaches. The big houses are a political issue in the small village. As tree cutting still is.

▷ *Wild roses around the trees and ferns of this Carmel garden lend credence to the name, "The Rose Cottage."*

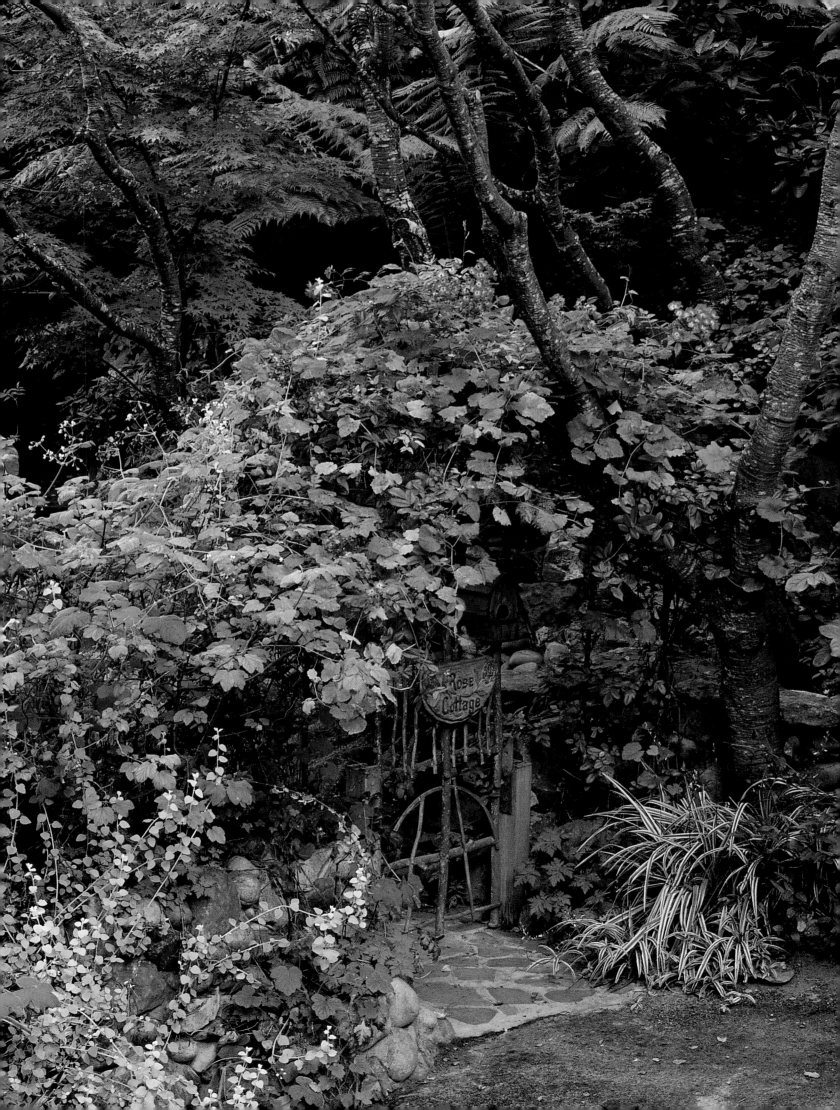

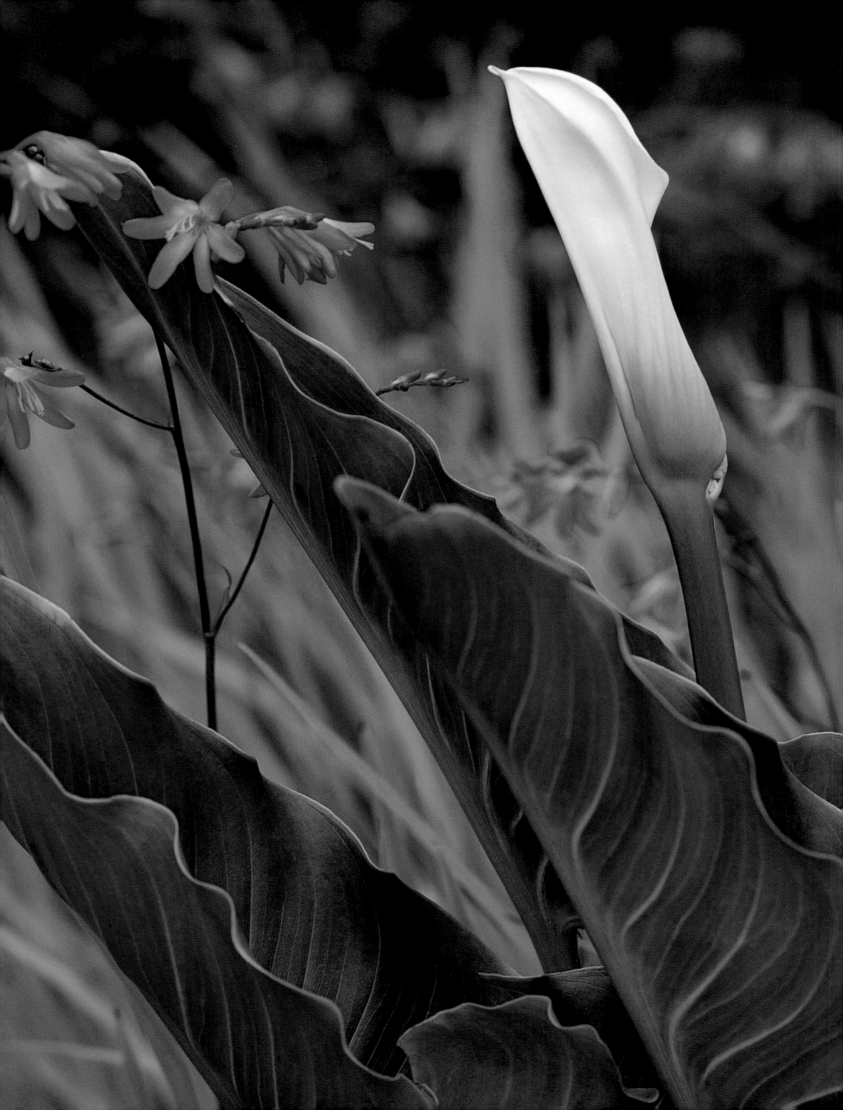

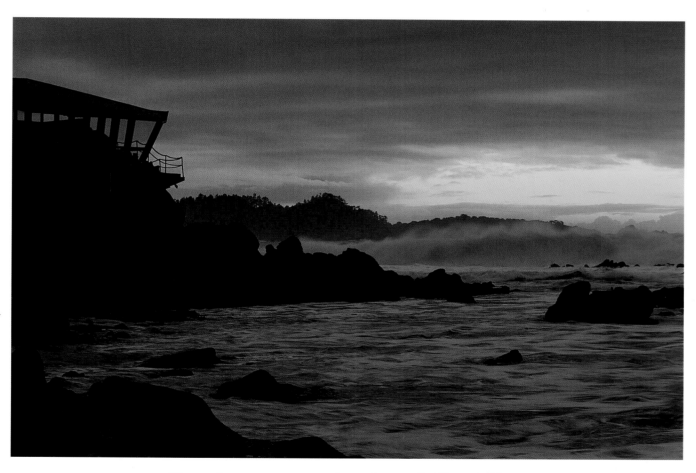

◁ Tiny red stars seem to watch a velvety calla lily as it blooms.
△ A house at Carmel Point is one of very few on the water in
Carmel. Its deck hangs out over the waves that crash in Carmel
Bay. Point Lobos sits across the bay.

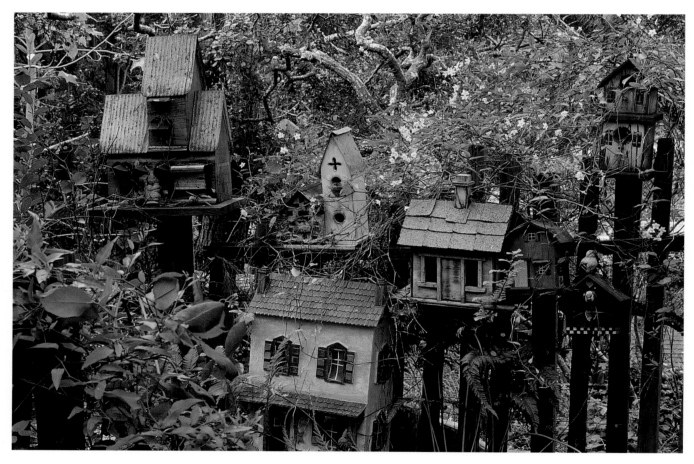

△ Birdhouses placed among the plants and trees in this yard seem almost like a miniature version of old Carmel-by-the-Sea. ▷ These windows display the character typical of even the newest structures in Carmel—a balcony around a shuttered window, a ledge under an arch, with potted flowers to highlight the designs.

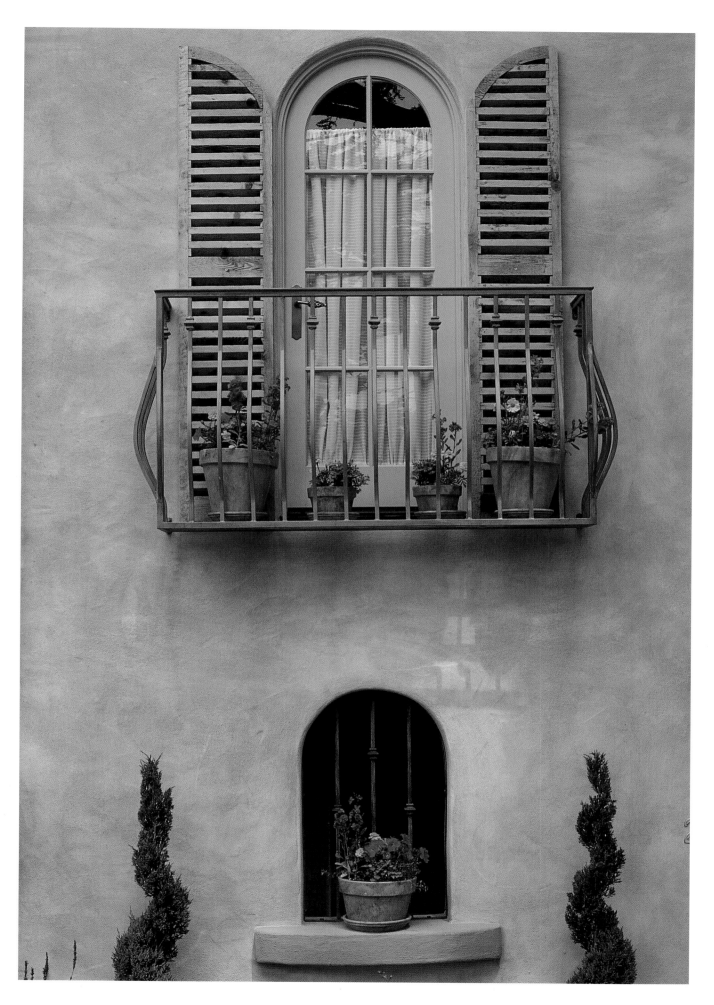

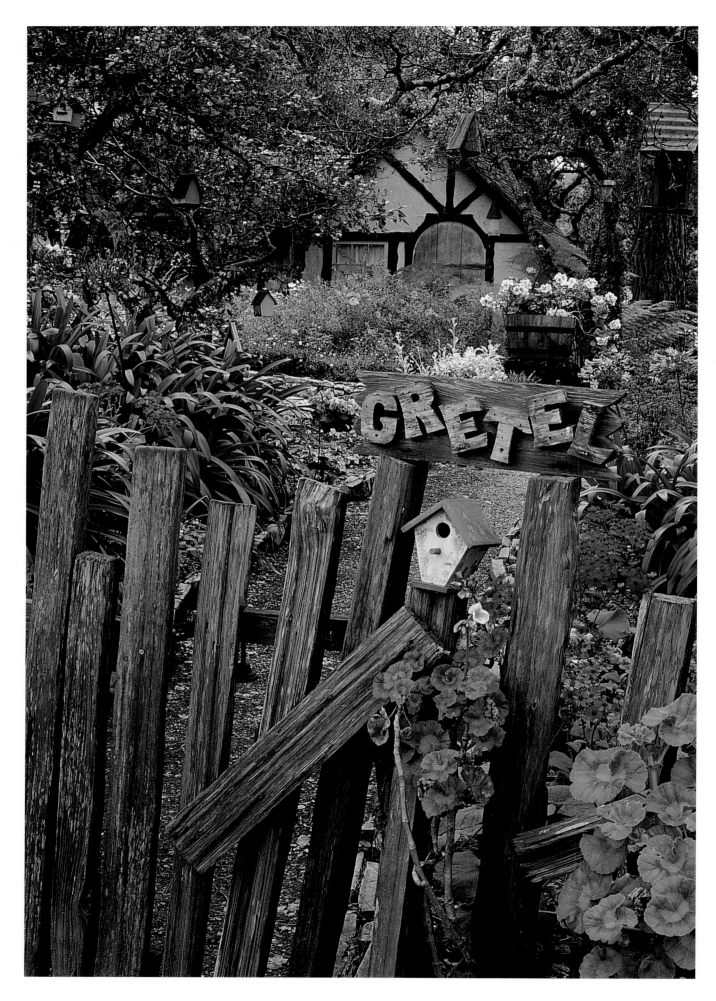

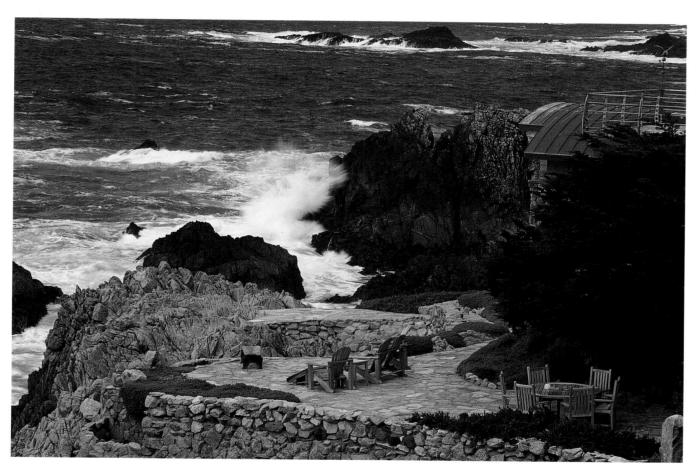

◁ "Gretel," the house Hugh Comstock built in 1924 for his wife, Mayotta Brown, and her Raggedy Ann dolls, started an era of whimsical, fairy-tale house construction in the village. "Hansel," the house the couple lived in, is located next door. △ A table for six, with lawn chairs nearby, sits waiting on a cliff that overlooks the crashing surf.

73

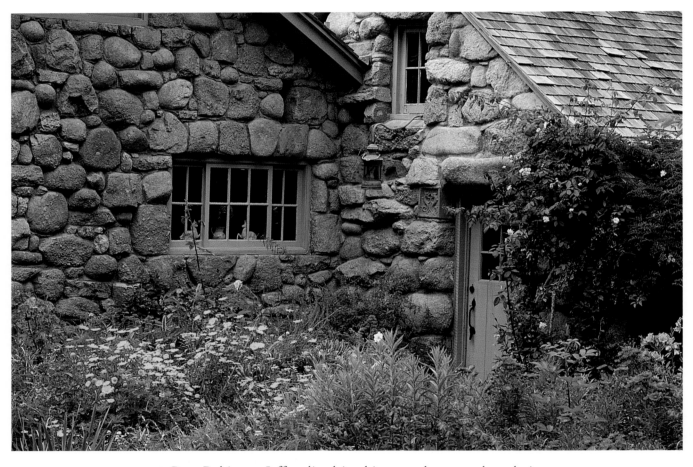

△ Poet Robinson Jeffers lived in this stone house and made it famous with his writings and visitors. The simple lines, natural materials, and beautiful garden are characteristic of Carmel homes. ▷ Picturesque features of Carmel houses show beautiful craftsmanship, such as this hand-hewn door on a home near the mission.

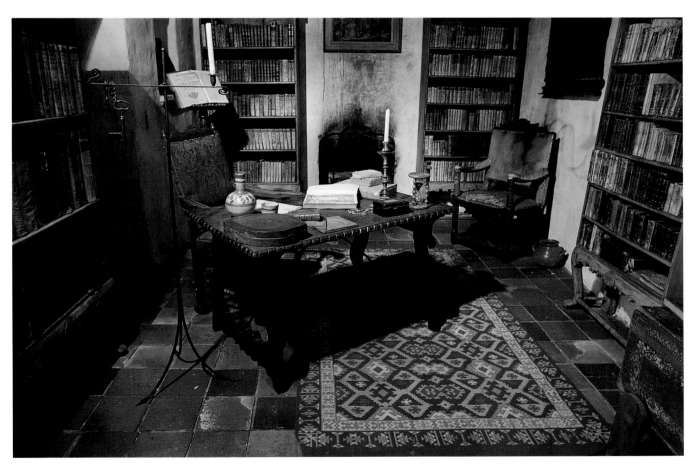

◁ Renowned architect Charles Greene designed and carved this flowering vine and pot design on the door of his home in Carmel. △ The library at Carmel Mission, the church started by Father Junípero Serra in 1771, still has simple bookcases, tables, and chairs.

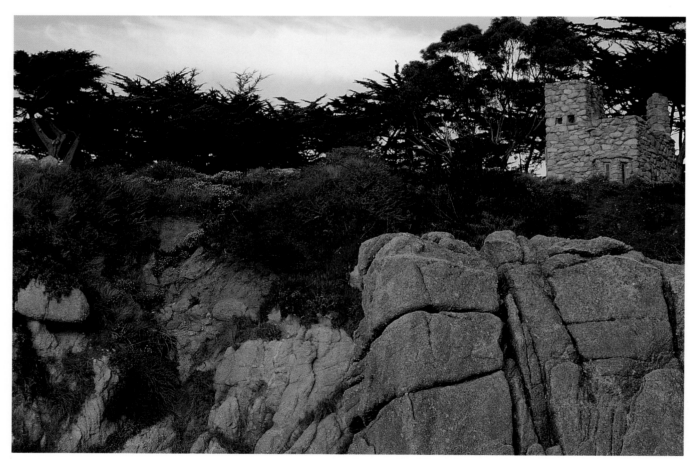

△ The stone Hawk Tower at Tor House near Carmel Point was hand-built by poet Robinson Jeffers after he and his wife, Una, moved to the village in 1914. It is now a national treasure. ▷ It's hard to tell what grows in this garden and what was added by whimsy. Such creativity is characteristic in Carmel gardens.

◁ A fountain at the Carmel Mission still displays the Spanish influence in the lines in its face, despite the softening of time. △ This statue by Jo Mora, one of Carmel's most successful sculptors, adds charm to the vines and hanging lamps in a quaint courtyard off Dolores Street near Seventh Avenue. Such scenes aren't secrets, but they wait to be found by discoverers willing to explore out-of-the-way places in Carmel.

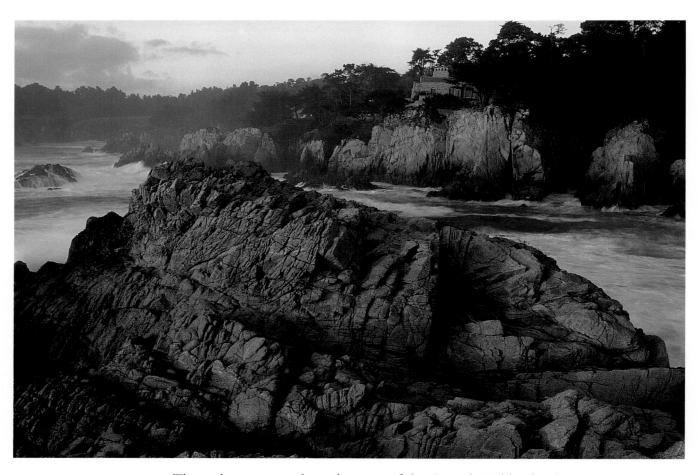

△ The rocky outcrops along the coast of the Carmel Highlands turn geology into an art form, providing exquisite sites for a number of mansions. This old-world stone house, built in the 1920s, is the masterpiece of famed architect Charles Greene. ▷ A courtyard door of an art studio in the downtown area of Carmel fits right in with the blooms and vines.

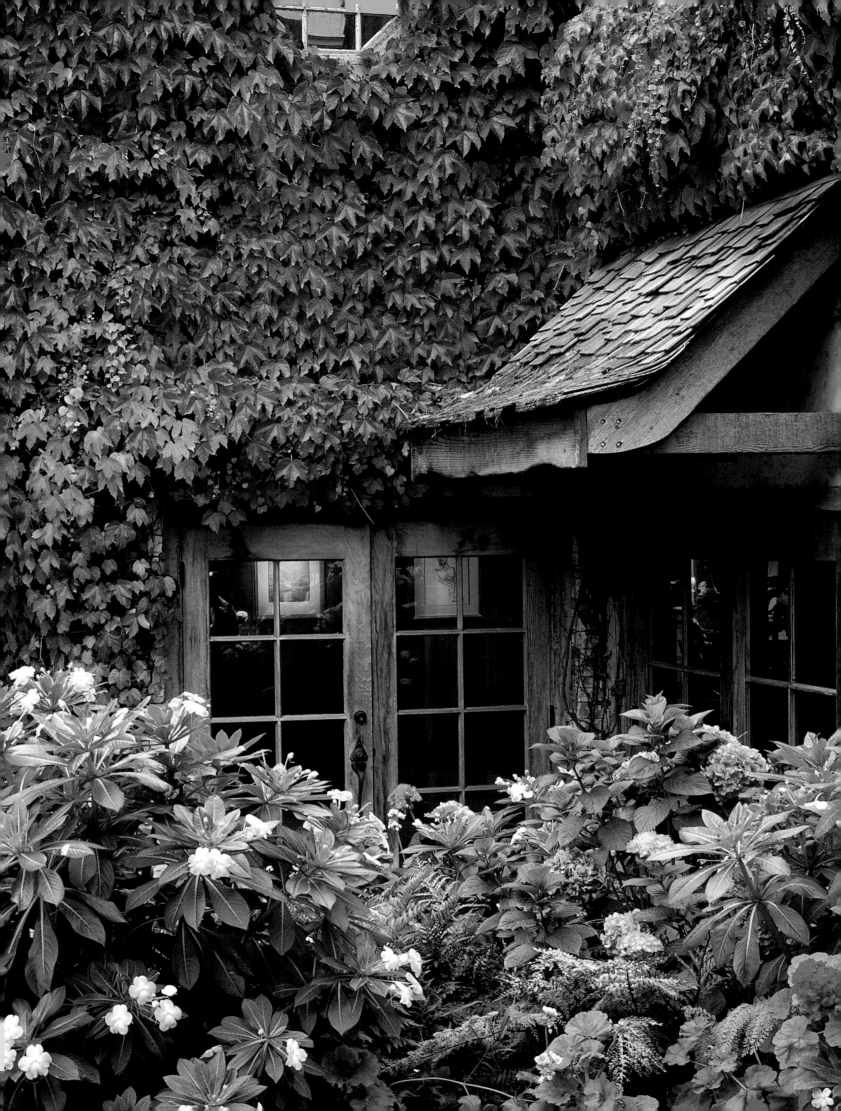

The people who lived here first—more than four thousand years ago, according to carbon dating of some of the shell jewelry and bones they left behind—depended on the land for survival. They gathered acorns from the oaks, soaked out the bitterness, and ground them into flour. To this diet staple, they added pine nuts, wild berries, grass seeds, fish, deer, rabbits, and whatever else happened by.

When the weather turned cold, they rubbed mud on themselves for protection. When they got warm, they washed it off in the river.

They were the Esselen, a tribe of Indians that probably never numbered more than twelve hundred, a rural people who roamed in the hills of Carmel Valley, Big Sur, and other parts of the Santa Lucia Mountains. They lived in thatch huts in the temperate climate and survived almost everything until white settlers arrived in the latter part of the eighteenth century. Until that point, the Esselen's major threat had been the grizzly bear.

But the settlers brought diseases, different diets, slavery, and soldiers which together killed off most of the Indians. Esselen who resisted—or escaped from—the Spanish settlers at the Carmel Mission were tracked down by the soldiers. A few retreated deep into the rugged mountains of Upper Carmel Valley, where they could outmaneuver the horse-mounted soldiers and survive. Some of their descendants still live in the area, much of which is now the Ventana Wilderness section of Los Padres National Forest.

The Esselen found protection in the hills. But most of the settlers in this area chose to live in the big valley carved through the Santa Lucia Mountains by the Carmel River. Some of the hills alongside are now sprinkled with rooftops, some with golf courses, some with vineyards, and some with riding and hiking trails. However, most of them are still covered by forests—oaks, predominantly, with some

alder, laurel, maple, and redwoods—or the sloping grasslands that serve as pasture for cattle and horses. The bulk of settlement is in the fertile floor of the valley itself, cuddled by the hills and warmed by plenty of sunshine.

The missionaries who started the Carmel Mission in 1771 were the first non-Natives to settle here. They planted orchards of fruit trees, rows of crops, and established dairies in the lower part of the valley, near the mission. The Americans who arrived in the middle of the nineteenth century carried on these agricultural practices and supplied peaches, cherries, pears, almonds, vegetables, and dairy products to the growing markets in Monterey.

Homesteading started in 1879, when a bear hunter named Jonathan Wright built a cabin on a San Clemente Creek clearing previously used by the Indians as a ranch and by a French pirate as a hideout.

In 1881, the resorts began to appear, after Monterey's posh Hotel Del Monte built the first dam on the Carmel River to get better water for its well-heeled guests. The hotel developed a ranch house and cottages in the peaceful area to offer side trips to its guests.

Subdivisions started in the 1920s, and houses and summer cabins popped up. In the 1930s, the roads were improved and more resorts emerged, more subdivisions sprang up, and shopping centers arrived for the growing population.

Today there are thousands of houses in Carmel Valley, many inns and resorts, a half-dozen golf courses, and five shopping centers, along with several wineries and some remaining orchards, farms, and ranches. The wineries—nine of them—are the latest and probably the widest-known use of the valley's fertile soil. Some of the wines have gained international fame since the commercial planting started in 1968, and some of the wineries—Bernardus, Joullian, Robert Talbott—have become common names among wine connoisseurs. The Carmel Valley vineyards range from two to two hundred and twenty acres, and the wineries bottle from six hundred to eighty thousand cases of wine each year.

◁ *The red of these grape leaves in Carmel Valley indicates that they are cabernet sauvignon vines, whether fruit is visible or not.*

There are many wine varieties, but the reds clearly predominate, especially cabernet sauvignon. The rocky soil on the higher ground that's good for deep-rooting oak trees seems equally hospitable to cabernet sauvignon vines, and the hillsides that slope into the sun allow the lush fruit to ripen to its full richness and complexity. That's not to say there aren't some excellent chardonnays and sauvignon blancs bottled in Carmel Valley. But warm days in the nineties and cool nights in the forties seem to favor the reds.

Carmel Valley Road is the major highway that links the valley's features, a road with four lanes at places and scores of intersections where smaller roads and lanes snake off to the sides.

The scenery along the road is lovely. There are houses and stores, of course, and gas stations, schools, and churches, but the road also curves around white board fences with horses romping behind them in peaceful pastures; it travels under pine trees that tower above shrubs and colorful wildflowers; and passes golf courses that offer rolling fields of green. All of this is framed by hills that rise gently, going up to two thousand feet with slopes of grassy meadows and leafy forests. And there are usually blue skies and sunshine overhead, at least more than at any other part of the Monterey Peninsula.

But as pretty as the valley is, it can be a difficult place for a country drive. The traffic on Carmel Valley Road is heavy and usually moves at a good clip as people rush to jobs, schools, stores, and appointments.

Some of the side roads can be dangerous—narrow, winding roads with blind curves, cliffs, one-lane bridges, and local drivers tearing through them like they are raceways. But these are the roads that lead to breathtaking hills that seem to roll along forever.

In the spring there are fields of blue lupines swaying in the breeze, the reds and oranges of Indian paintbrush, golden poppies accenting everything, and grasses and trees in every shade of green. Many creeks, gurgling with runoff water from the winter rains, ripple through the valley. In summer

and fall, the fields and meadows turn gold and brown and many of the creeks are dry.

The hills in the distance always look blue, a hue that possibly results from fog and light, dust and sun, or just imagination. But up close they are almost always green.

When you get into them—try the sixty miles of winding Carmel Valley Road from Carmel to the Salinas Valley if you're adventuresome, or the narrower Cachagua Road in the upper valley if you're really daring—you see rounded hills rolling gently from one to another with no end in sight. Only occasionally is there a jagged peak, a deep cut, or a wall to show the evidence of a slide over the years, a collapse of rain-soaked mud that slipped down to make the valley fertile. This phenomenon of nature leaves rockier soil in the upper reaches, the home of deep-rooted trees and seasonal grasses.

There are only a few places high up in the valley where the hills separate and reveal the Pacific Ocean in the distance, spellbinding views of infinity.

If you travel to more remote spots, you are more likely to see the wild boar that were first imported from Russia in 1923 for hunters on the giant San Carlos Ranch, or the bunches of wild turkeys that gobble across the hillsides, or the eagles that sometimes dominate the sky. If you get near the clear water of the higher reaches of the Carmel River or one of the bigger creeks that flow into it, you might see steelhead trout swimming gracefully past.

At night, unless the ocean fog has blanketed the valley or the winter rain is falling, you'll almost always see a starry sky with a silver moon in the passing phase of the month. You might hear a call of the many owls in Carmel Valley or the piercing cry of the mountain lions that are part of this unspoiled environment.

▷ *A lizard blends in with the cracked paint on a door of an old barn at Garland Ranch. Trying to trace its tail is something like looking for Waldo's face in a crowd.*

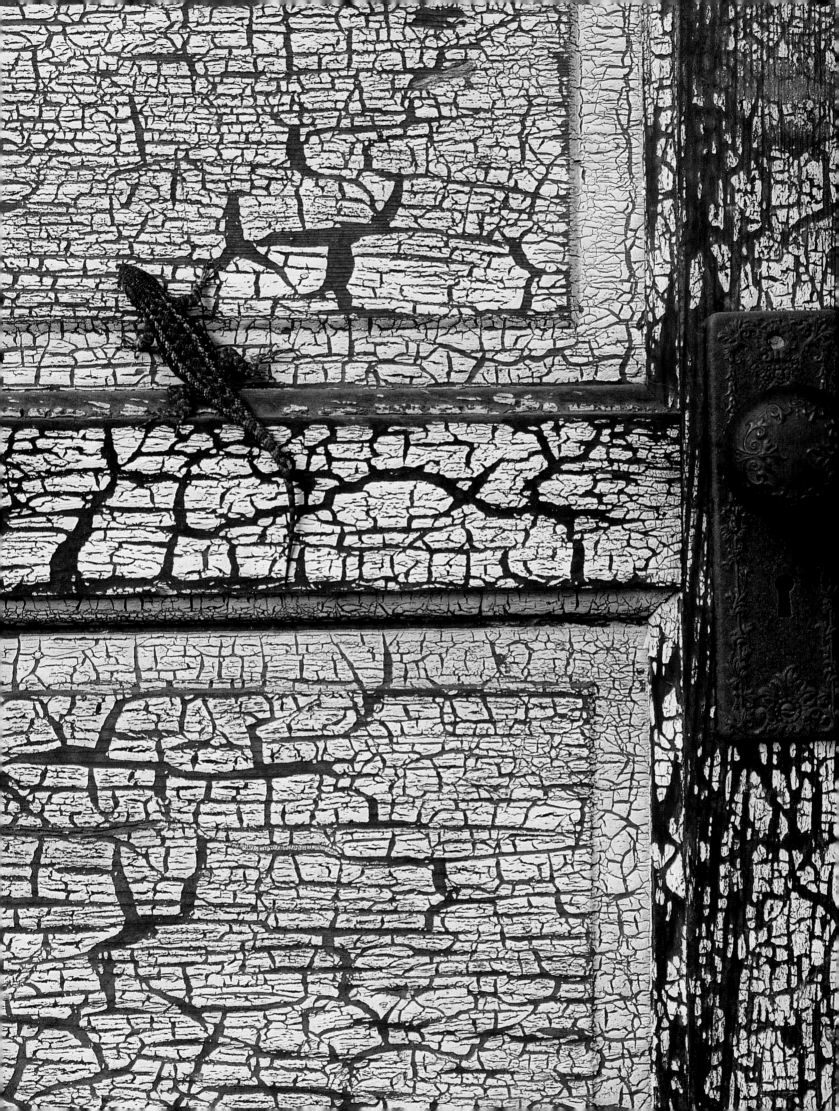

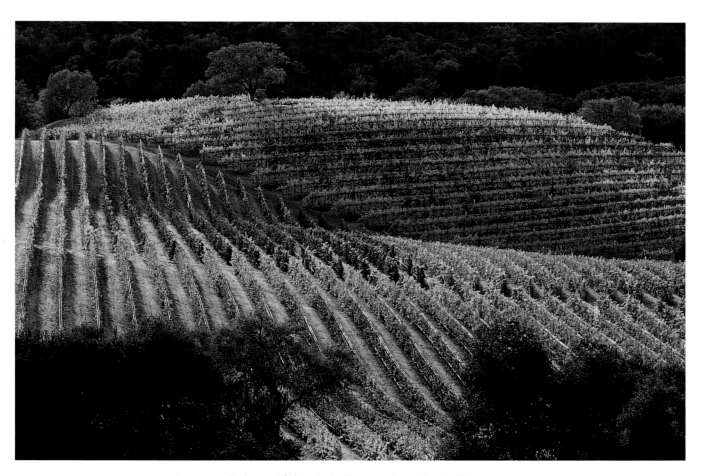

◁ As serenely beautiful as it is threatening, the brilliant autumn colors of poison oak intermingle with the green of a pine tree. △ Grapevines roll with the hills at the picturesque Joullian Vineyards, off Cachagua Road in the upper part of Carmel Valley.

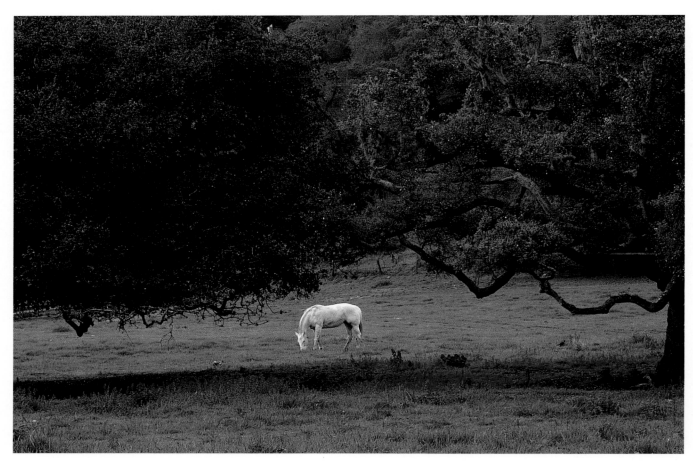

△ Pastoral scenes such as this horse munching among the oaks are still plentiful in Carmel Valley, despite pressure for development.
▷ The twists and bends of an oak tree in Robinson Canyon look almost ghostly in a heavy fog that settled in at sunrise.

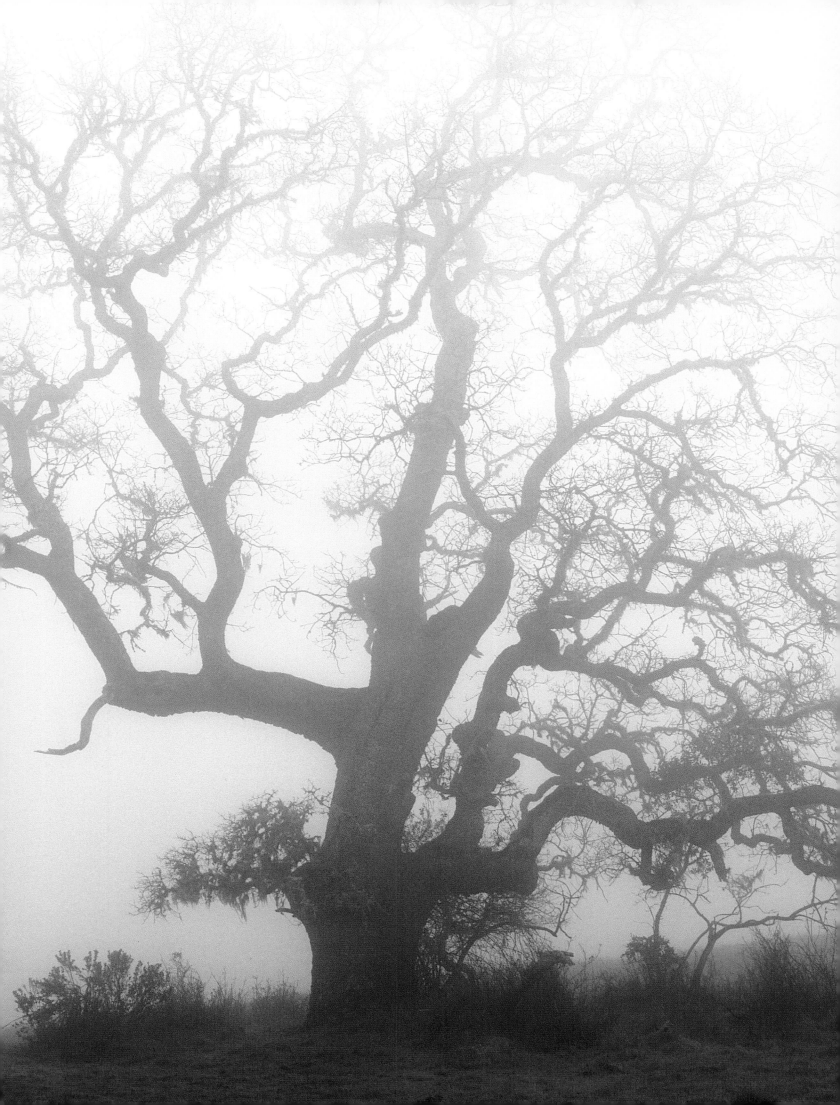

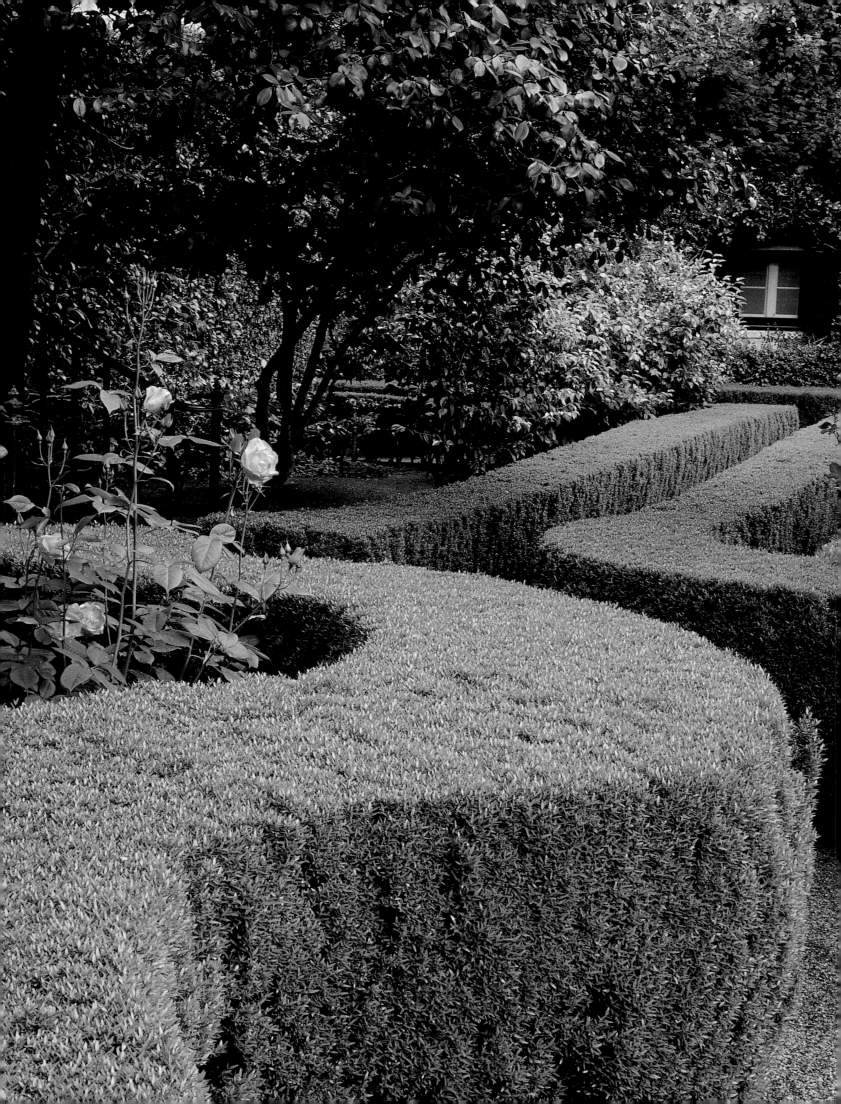

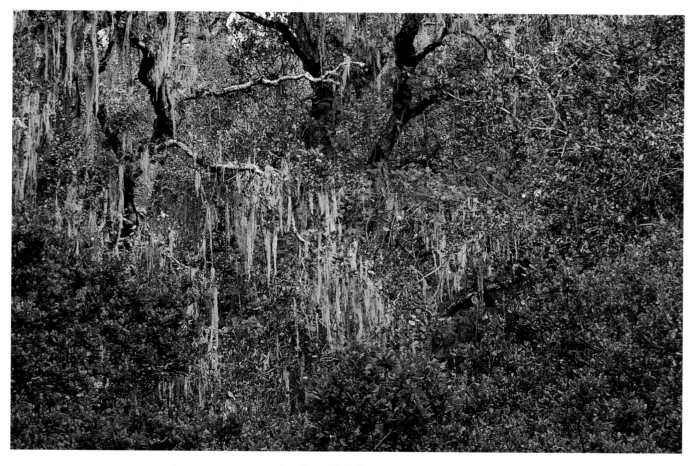

◁ At a country estate in Carmel Valley—now Stonepine Resort—
sculpted hedges border a path among colorful roses and camellias.
△ Chaparral, oaks, and lichen that hangs like Spanish moss form
a typical scene in Carmel Valley.

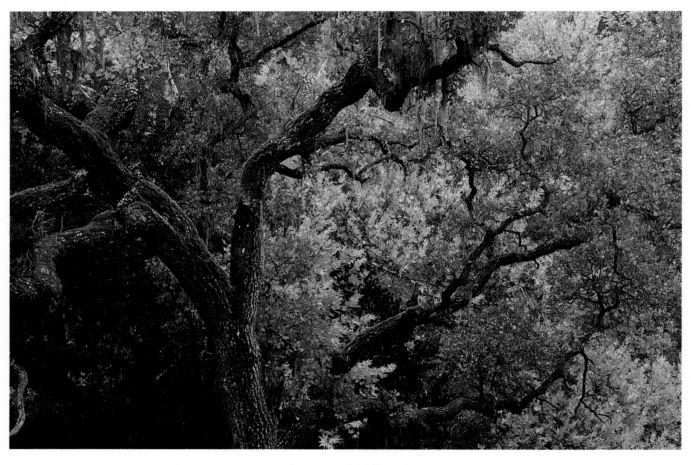

△ During autumn in the Carmel Valley, the sycamore trees add their bright golds and yellows to the reds and greens of the oaks.
▷ In the spring, lupines wind along the roadsides and up the hillsides, creating blankets of pastels for the landscape.

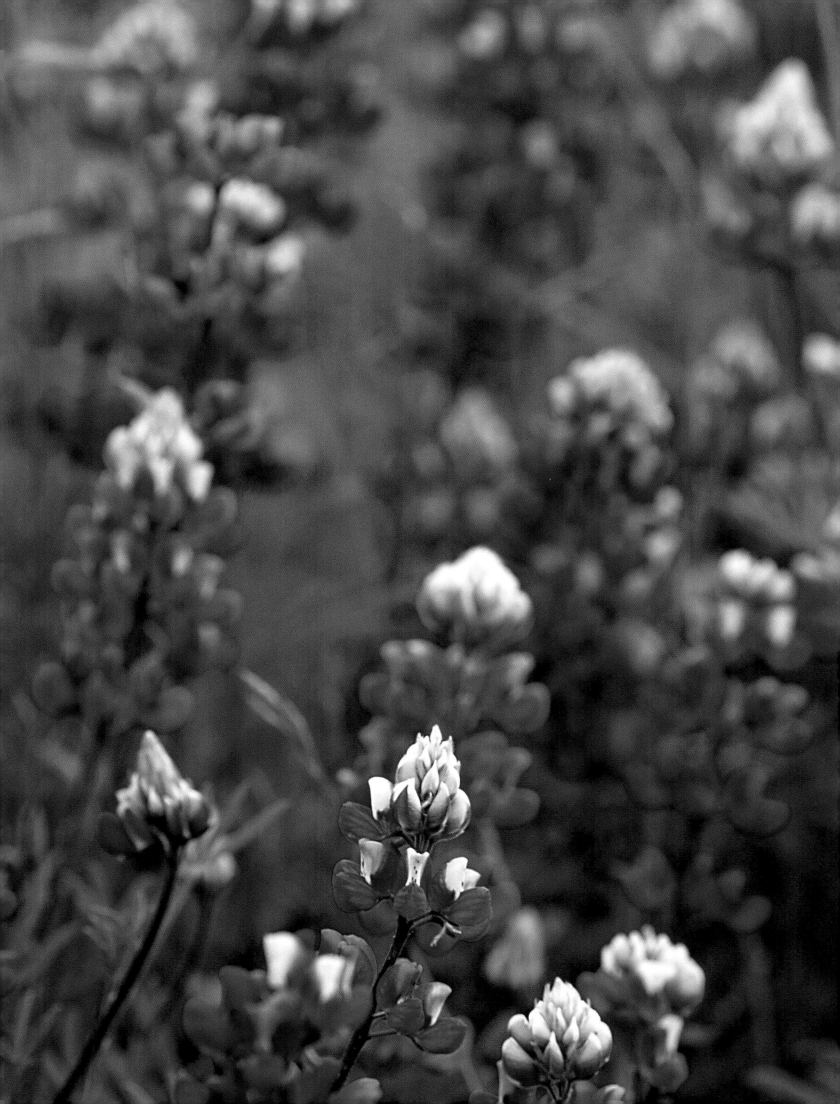

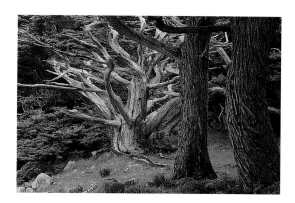

Point Lobos could easily be Treasure Island. There, that rock high above Whalers Cove, that could be Spyglass Hill, where a lookout can stand and watch for activity along the mainland. From there, you can clearly see Carmel and Carmel Bay, Stillwater Cove and Pescadero Point up the coast in Pebble Beach, beaches and river mouths along the shorelines, Carmel and Pebble Beach rooftops among the pine trees, and the quaint bell tower of the Carmelite Monastery.

Or that could be Spyglass Hill over there, the headland above Sea Lion Rocks. A lookout can watch fishing boats and passing ships that might, with a little imagination, be the galleons of pirates flying the Jolly Roger and looking for the island where Captain Kidd buried his stolen treasures.

Even that could be Spyglass Hill, the flat-topped outcropping by China Cove, now called Pelican Point. It offers a view to the world's horizon, and a look down the shore to Carmel Highlands and the rocky coastline of Big Sur.

Any of these overlooks could be the Spyglass Hill that Robert Louis Stevenson wrote about in his classic children's story *Treasure Island,* a book he wrote after living on the Monterey Peninsula. He described it as the biggest of three hills on the island, a great bulk that sometimes had a cloud on it and a side that "descended almost to the sea in formidable cliffs," like these do.

As Stevenson saw it from the sea:

Now, right before us, the anchorage was bounded by a plateau from two or three hundred feet high, adjoining on the north the sloping southern shoulder of the Spyglass, and rising again towards the south into the rough, cliffy eminence called the Mizzen-mast Hill. The top of the plateau was dotted thickly with pine trees of varying height. Every here and there, one of a different species rose forty or fifty feet clear above its neighbors.

◁ *A close-up look at an abalone shell shows why these shells are prized for jewelry and mother-of-pearl buttons.*

And on the land:

I climbed a thousand times to that tall hill they call the Spyglass, and from the top enjoyed the most wonderful and changing prospects.

A purist can argue that none of the many points and hills and rocky outlooks at Point Lobos State Reserve matches Stevenson's physical descriptions exactly. The surrounding hills aren't totally as he described, the landing beaches aren't exactly where his writing placed them, and the vegetation doesn't quite match his descriptions.

There's also the fact that Point Lobos isn't an island. It's a peninsula with an amazing series of coves, outcroppings, and beaches. But it is very much part of the mainland of California and has been for thirty million years, according to geologists.

It's also possible that Stevenson never actually visited Point Lobos while he was living in the area in 1879. Scholars point out that his stories and journals never mentioned Point Lobos, which was a cattle ranch at the time, but he did write about visiting Carmel and the Carmel Mission across the bay, so presumably he looked over and saw the craggy rocks that jut out into the Pacific, something like an island.

The island of *Treasure Island* was imaginary, Stevenson scholars say, concocted from the author's observations in California and the Scottish Highlands and his reading about pirates in the Caribbean. But there's enough of *Treasure Island* at Point Lobos to satisfy the imagination.

The place was entirely land-locked, buried in woods, the trees coming right down to the high-water mark, the shores mostly flat, and the hill-tops standing round at a distance in a sort of amphitheatre, one here, one there . . .
Then I came into a long thicket of these oak-like trees—live, or evergreen, oaks, I heard afterwards they should be called—which grew low along the sand like brambles, the boughs curiously twisted, the foliage compact, like

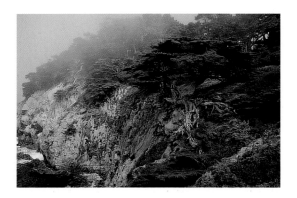

thatch. The thicket stretched down from the top of one of the sandy knolls. . . .

Live oaks, tall pines, and the redwood trees of Stevenson's island, in addition to peaks emerging from the fog, can't be found together in many places in the world. Shiver me timbers if Point Lobos isn't one of them, and an isolated enough area to attract the likes of Long John Silver.

The wonderful coves are here too, and the small beaches and jagged rocks for the foaming surf to pound against. The sky sometimes fills with birds. And there are the barking sea lions that Stevenson described:

> *Crawling together on flat tables of rock, or letting themselves drop into the sea with loud reports, I beheld huge slimy monsters—soft snails, as it were, of incredible bigness—two or three score of them together, making the rocks to echo with their barkings.*
>
> *I have understood since that they were sea lions, and entirely harmless.*

We now know that the barking sea lions—sea wolves, or *lobo marino*—are generally harmless unless you have hooked a salmon that a nearby sea lion wants for lunch.

Whether there is any pirate treasure buried at Point Lobos is something best left to the imagination. But certainly natural treasures are bountiful, even after many have been found and taken from the place for profit.

California bought Point Lobos in 1933 to preserve its unique beauty forever. The state wanted to protect the gnarled Monterey cypress trees that decorate the westernmost part of the area, one of the last two stands of what was once a large forest of wind-sculpted cypress. The nature preserve has since grown to 1,325 acres, with 775 of those under the water that surrounds the capes and coves and all their offshore rocks.

The land preserve includes the increasingly rare, native Monterey pine trees, an artist's dream of coastal redwoods that shoot up like poles with umbrellas at the top, live oaks with moss-like lichen hanging down, and sedges and grasses that wave in the breeze. There are wildflowers of every design where you least expect them, rocks in all colors and textures, white sandy beaches, inlets of jade green water, wide reaches of deep blue ocean, waves crashing into geysers against the rocks, and headlands that show the cracks of age. The foaming surf thunders onto the shore in some places and rolls in gently like a lapping tongue in others.

There are ever-enchanting sea otters swimming in the kelp and, mostly in the spring, teaching their pups to dive for shellfish and then smash them open on their bellies. Harbor seals flop up on the beaches, while sea lions clamber over offshore rocks to converse and rest. Cormorants nest on the rocks, as do western gulls and pigeon guillemots. Whales pass by during their winter and spring migrations and sometimes venture into the coves with their babies. Birds are usually plentiful, as are black-tailed deer and western gray squirrels. But you'll rarely see the bobcats, coyotes, and owls that come out at night, after the reserve is closed to human visitors.

Before the state preserved this "Treasure Island," many people made their livings from the natural resources that once abounded at Point Lobos. They quarried granite, trucked out gravel, mined gold and silver, shipped coal, and took the fine sand off the beaches for the glass factories of the day. Others built a whaling station, an abalone cannery, and a fishing village. They used the meadows as cattle pastures, and grew crops like corn and potatoes. Around the turn of the twentieth century, a developer tried selling small building lots at Point Lobos for a new community two miles south of the fledgling Carmel. Fortunately for the wildlife, this plan didn't get far.

Bootleggers during Prohibition had gun battles here while unloading the whiskey that Canadian ships brought in.

And nearly fifty movies have been made at Point Lobos over the years, including *Treasure Island* in 1934, an MGM film that starred Lionel Barrymore, Wallace Beery, and Jackie Cooper. *Yo ho ho and a bottle of rum.*

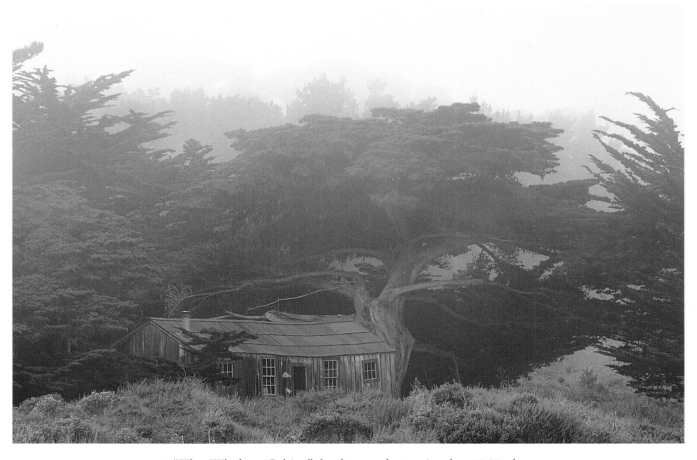

△ "The Whalers Cabin," built as a home in the 1850s by a Chinese fisherman, now houses the museum at Point Lobos State Reserve. It's been protected through the years by the hills of granite and the cypress trees that block the ocean wind.

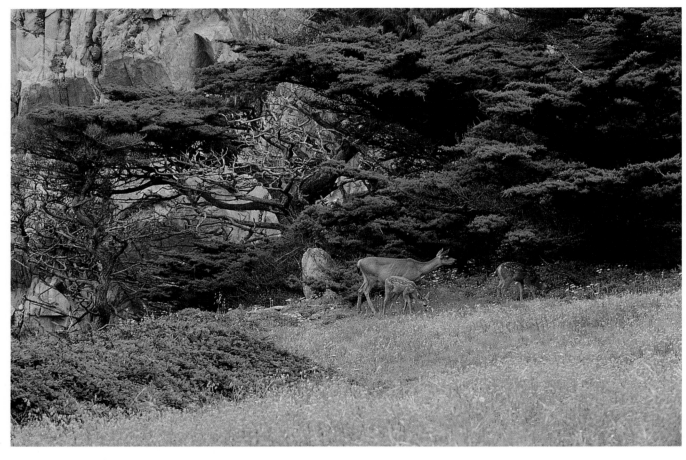

△ Seemingly oblivious to danger, a black-tailed deer and her two fawns feed on the plants under the cypress trees at Point Lobos. ▷ The treasure of any island can be seen on the cliff of Big Dome, a granite outcropping at Point Lobos. Old and new cypress trees appear to grow right out of the rock, along with the bright Indian paintbrush and the rosettes of the succulent bluff lettuce.

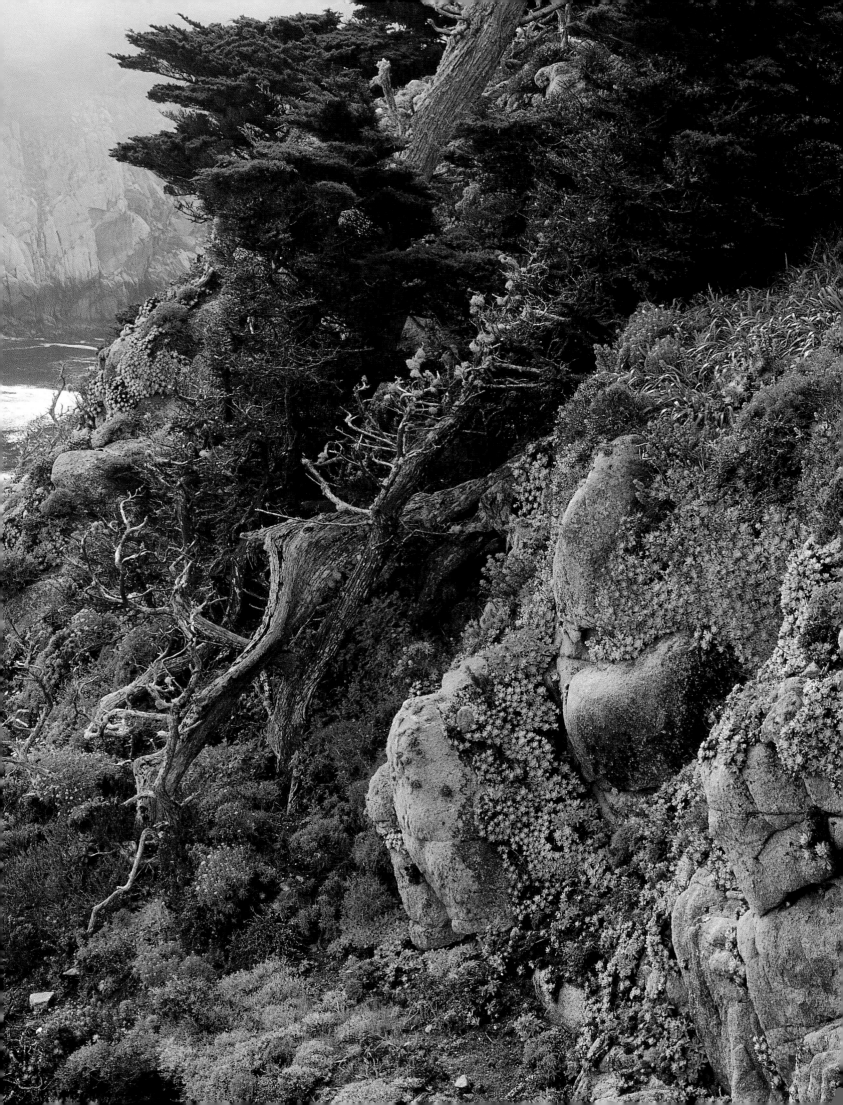

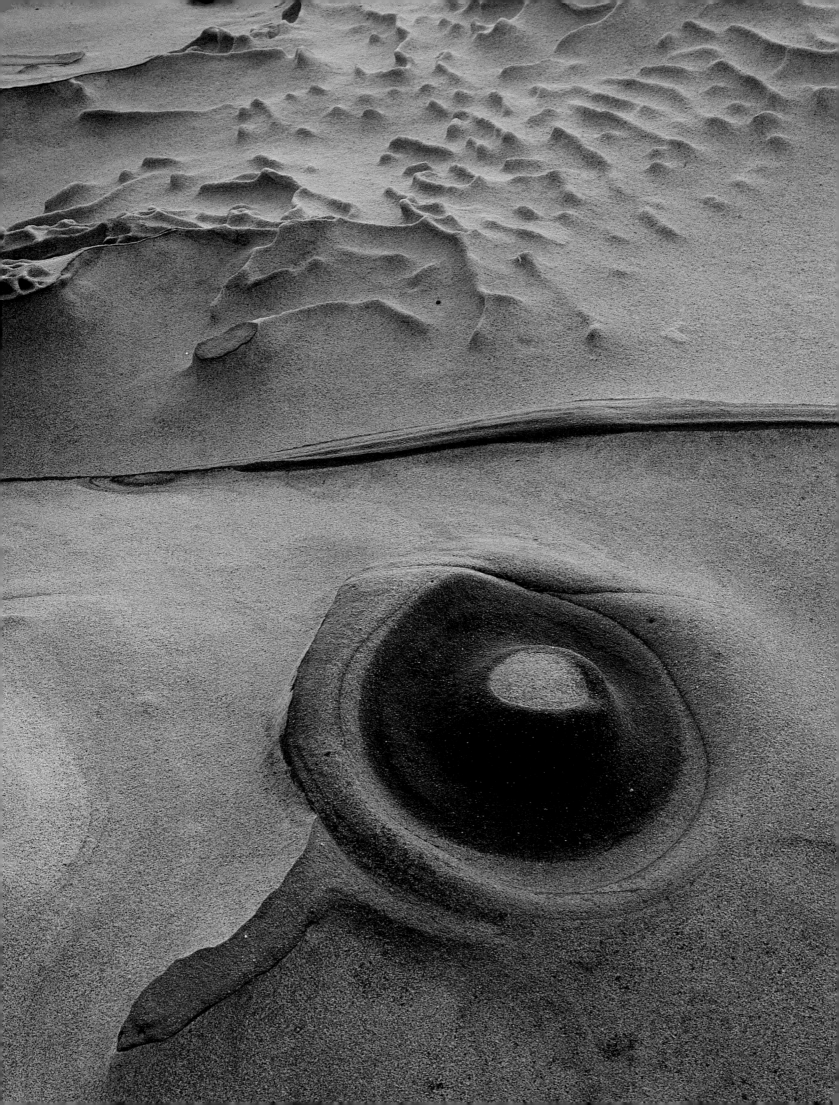

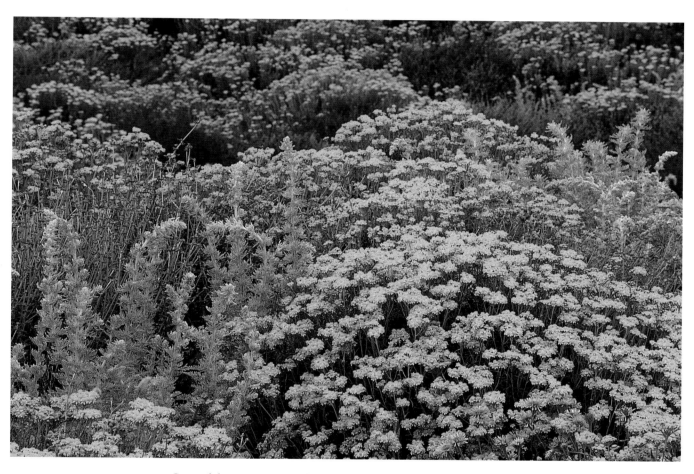

◁ Carved by centuries of water and wind, the rock formations near Sea Lion Cove at Point Lobos look like moonscapes. These circles and ripples are in a sandstone known as Carmello rock. △ A Point Lobos landscape features the feathery-looking forms of beach sagewort, the pink flowers of seaside daisies, and the yellow blooms of lizard-tail yarrow.

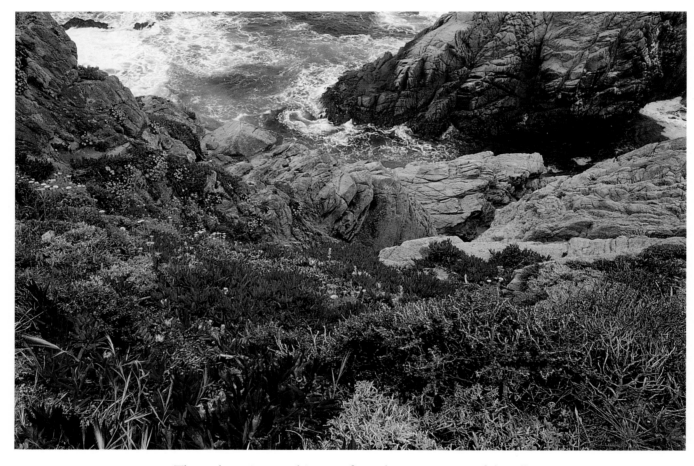

△ The rocky points reaching out from the cypress trees of the Allan Memorial Grove form a steep slope down into the Pacific Ocean.
▷ Pelican Point didn't receive its name by chance. Brown pelicans, once endangered by the pesticide DDT, claim the point, while Brandt's cormorants claim the offshore rock known as Bird Island.

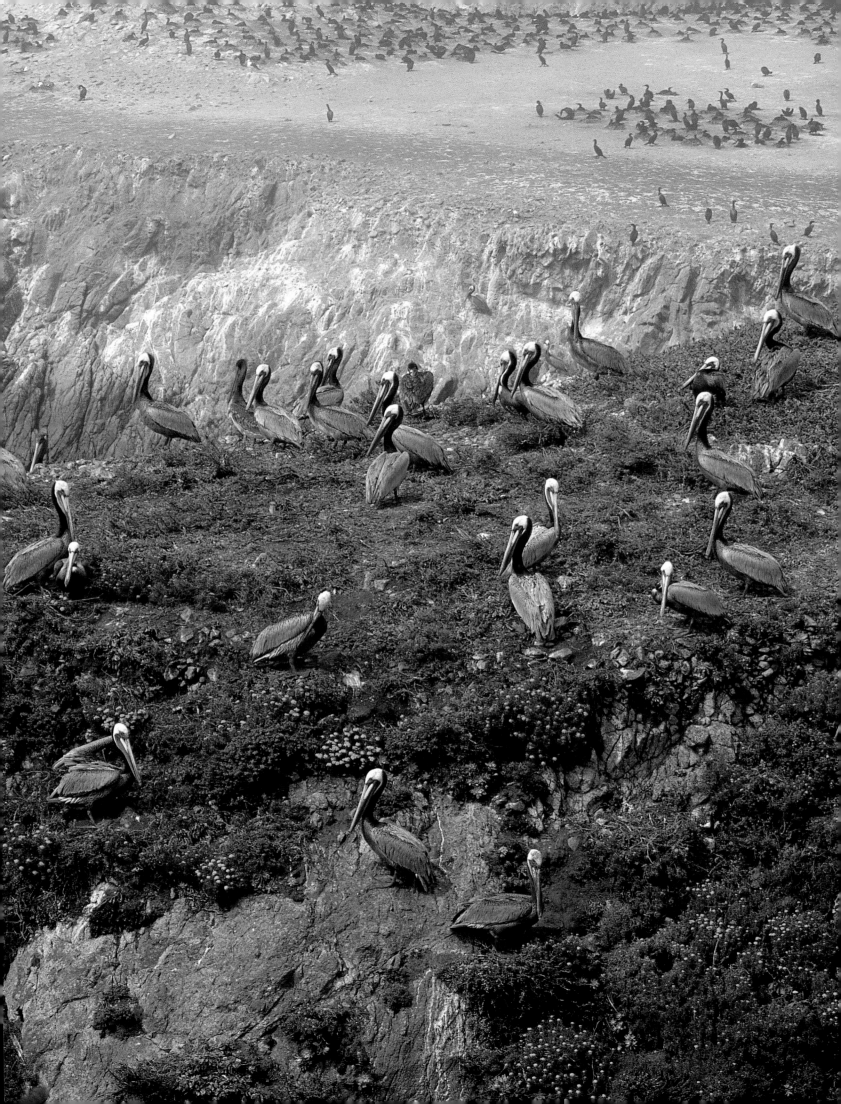

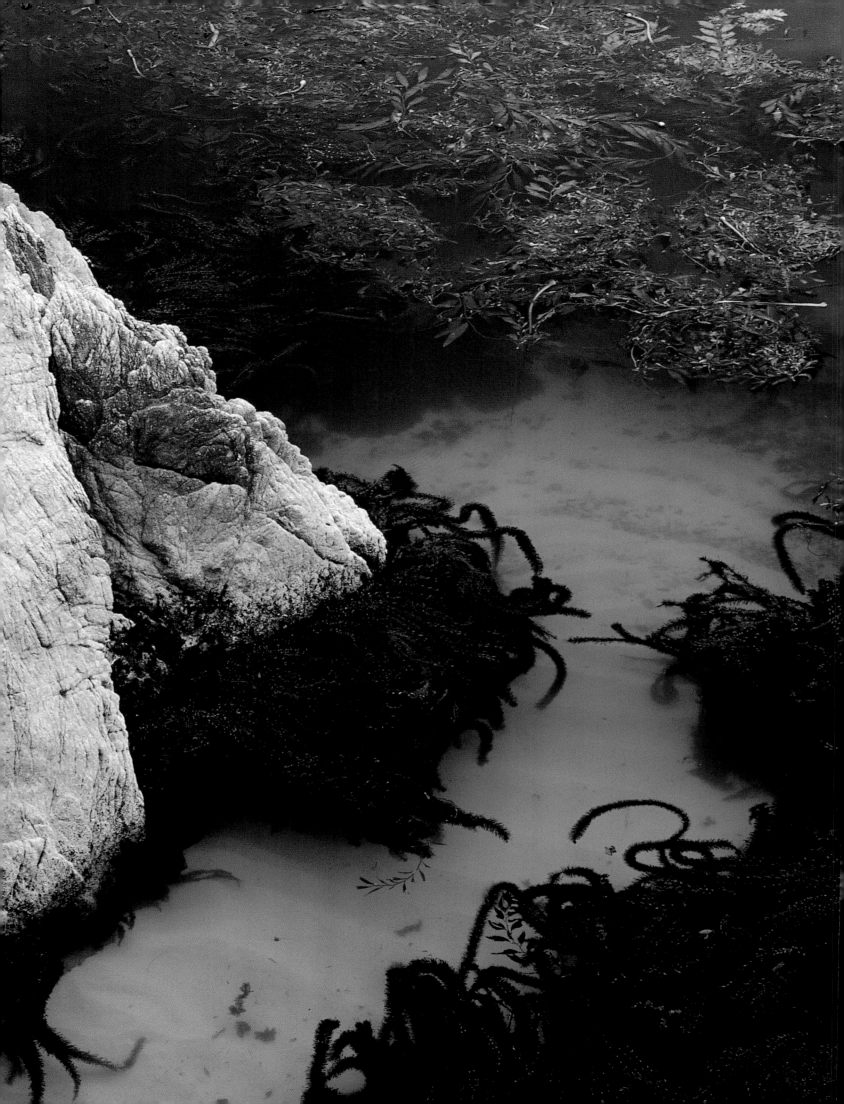

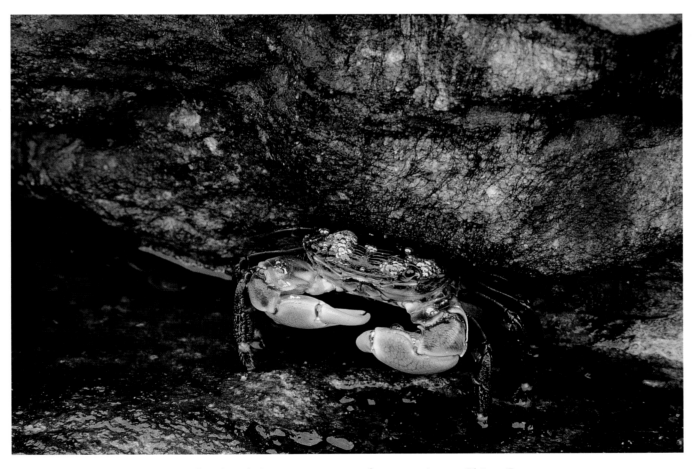

◁ Feather boa kelp seems to grow from granite at China Cove, while giant kelp caps the emerald green water of the beautiful inlet. △ A lined-shore crab guards its territory among the rocks. This marine critter is common along the shore of Point Lobos.

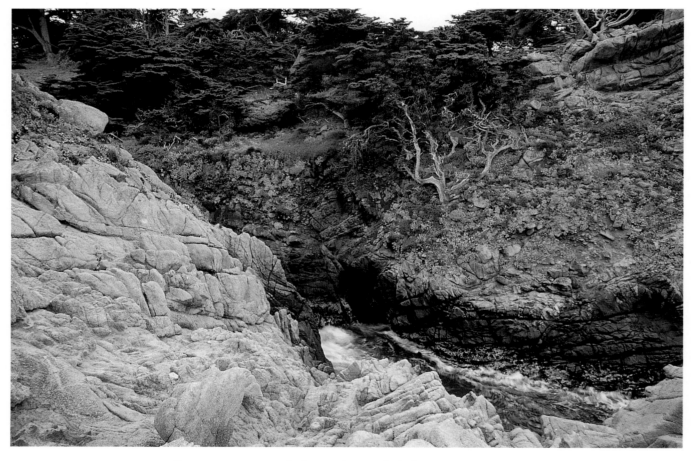

△ Cypress trees—including whitened skeletons—cling to the steep cliffs that border the inlets and coves at Point Lobos. ▷ The twisted branches of cypress trees hug the windswept shoreline around Headland Cove. Over the years, the powerful ocean wind has caused the trees to bend and fork.

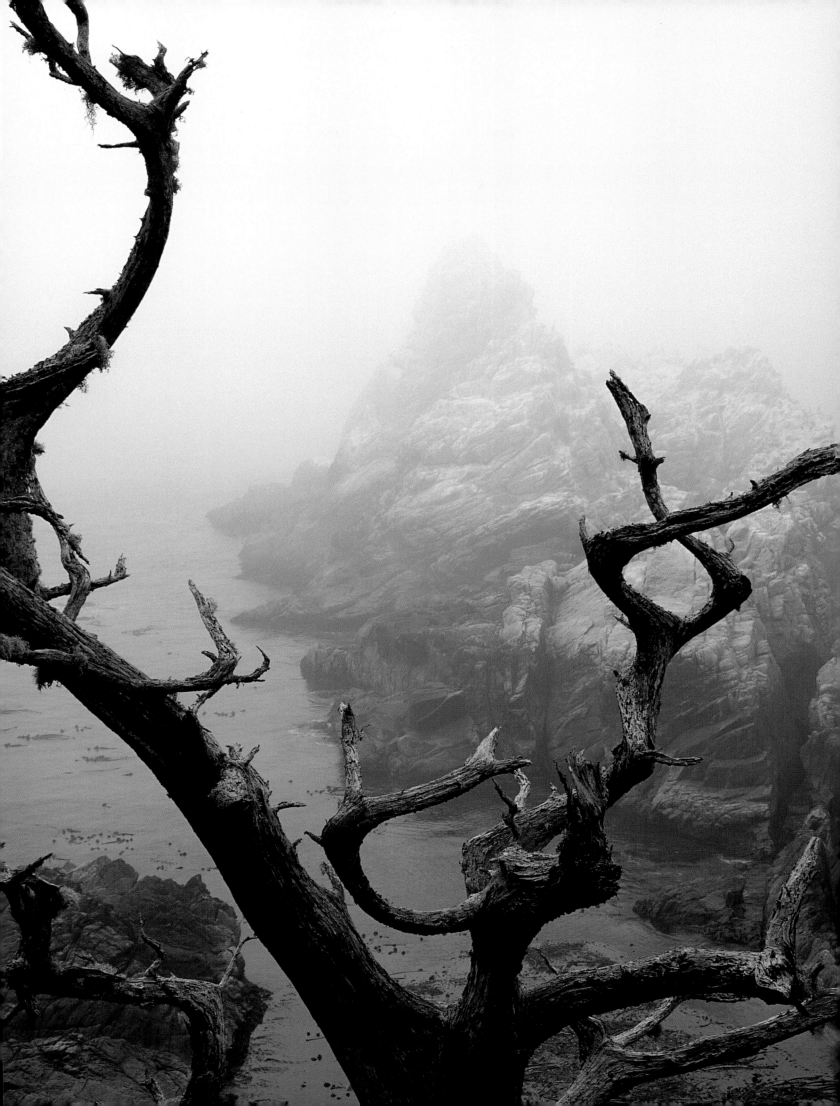

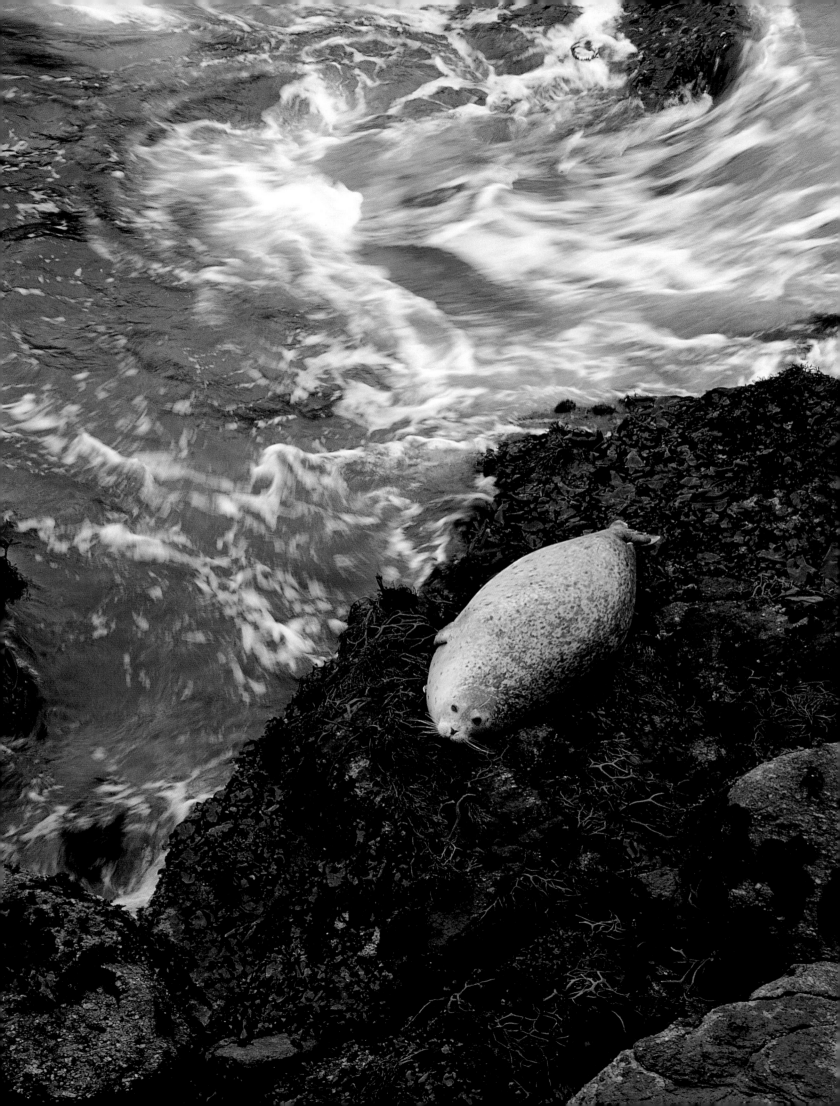

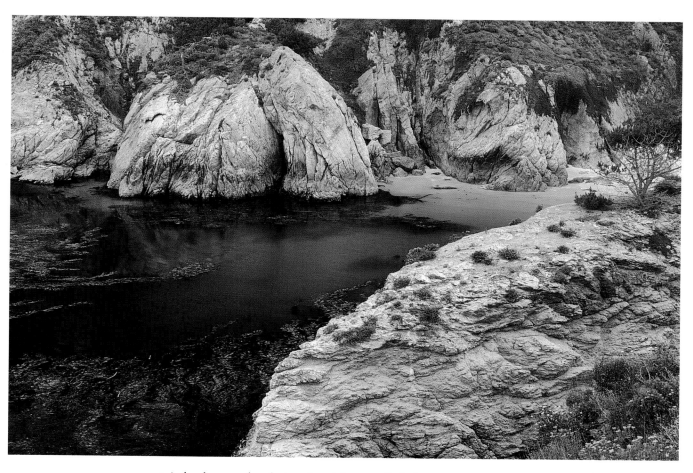

◁ A harbor seal, obviously either well fed or pregnant, rests quietly on a bed of lettuce kelp atop the rocks of Point Lobos. △ The beach at China Cove offers an intriguing, isolated fantasyland for those willing to climb down the steep rocks to get to it.

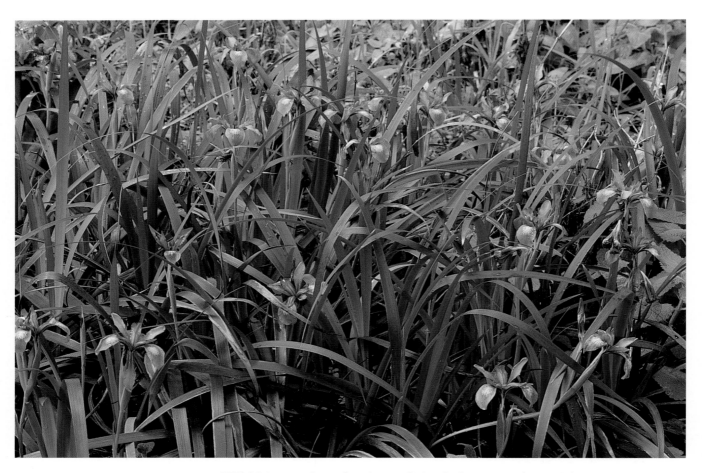

△ Wild irises, a sign of spring at Point Lobos, grow here with a patch of hedge nettle. They fill the forest floor with color and line trails throughout the reserve, usually starting in late winter, though sometimes irises reach full bloom earlier or later. ▷ Situated on a bend of the North Shore Trail, across from a point covered by pine trees, a cypress tree shelters a blue heron's nest.

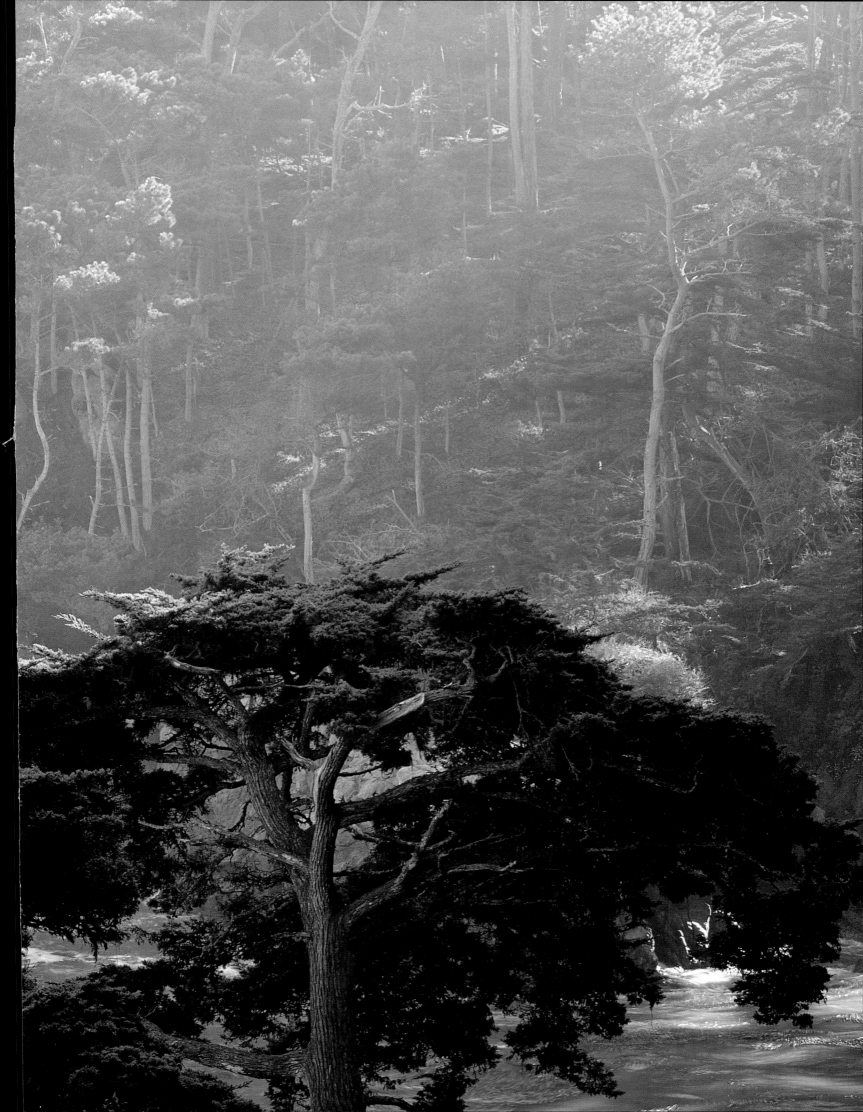

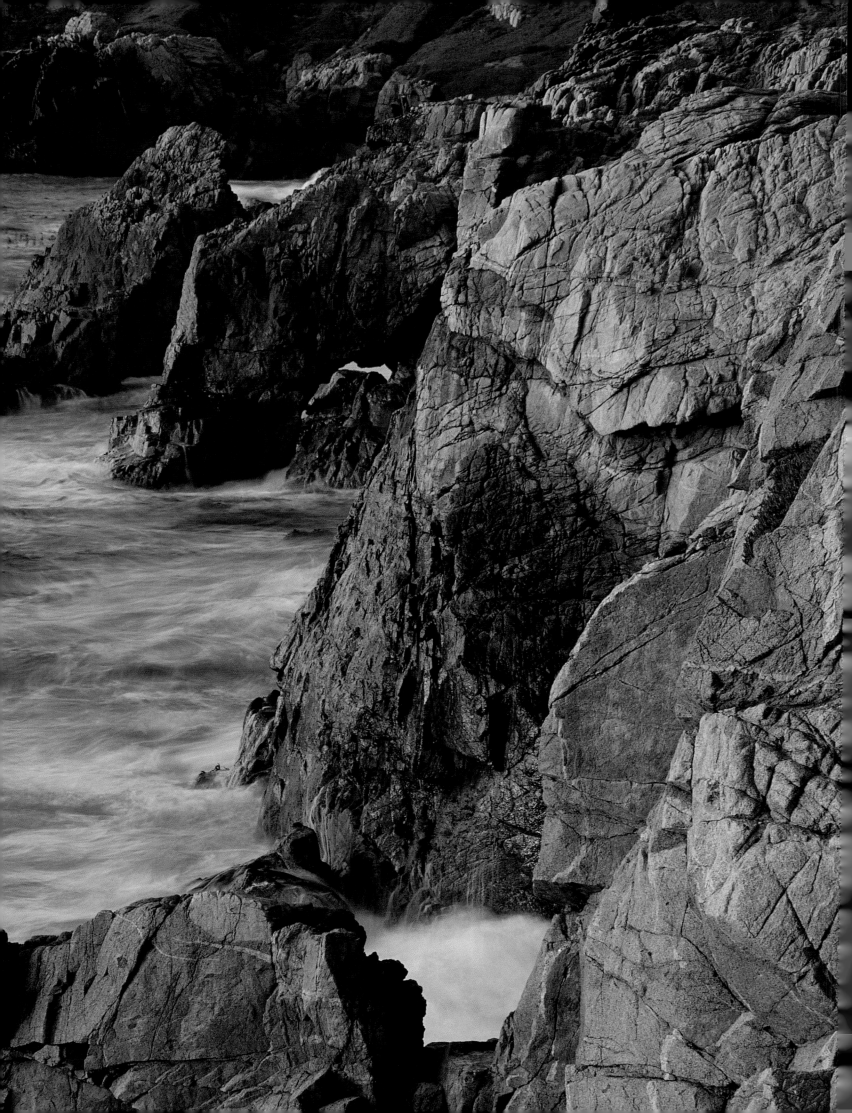

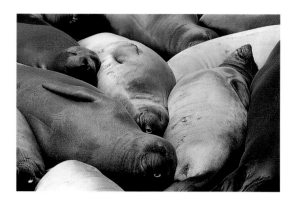

You're sitting beside the Big Sur River, watching crystal-clear water wash over the pebbles and rocks of the bottom, listening to it gurgle and whoosh as it rushes over the ripples and around the boulders. If you listen closely enough it can become a deafening roar, interrupted only occasionally by a whistle or shriek in the distance that reminds you there are birds among the cottonwoods and willows.

Walk a mile. You're standing in a redwood forest, looking straight up at the exquisite giants that are packed as closely together as survival will allow. The jagged branches at the top form tepee-like umbrellas that shade the forest floor so that it is cool and moist for the thick moss and lush ferns that soften it. This is the definition of quiet, of solitude, of peace.

Walk a mile. You're on a mountaintop, looking across the folds and crevices of rolling hills that rise and fall into the horizon like waves on the ocean. The hillsides are mostly meadows in all shades of greens, dropping into canyons that cut toward the Pacific and flow, sometimes steeply, to the pounding surf.

Walk a mile. You're on a cozy beach, nestled between a rim of rocky cliffs and the thundering ocean surf. Salty mist sprays across your face, you have to shout to be heard, and you are awed by the continuing power of nature. The ocean cuts holes and caves in the granite rocks, throws logs onto the beach as if they were toothpicks, and just keeps pounding away.

With pristine streams, redwood forests, mountains that rise more than a mile high, and isolated beaches all collected together within walking distance, you must be in Big Sur. It's a mystical, uniquely wonderful work of nature that humbles any human ego within minutes and puts life in its true perspective.

◁ *Lined up like shoulders nudging the sea, the granite rocks of the Big Sur Coast, like these at Sobranes Point, show the strength that has endured through the ages.*

Big Sur is a ninety-mile stretch of rugged coastline south of Carmel, quite possibly the most beautiful coastline in the world. But it's as much a state of mind as it is a place on the map. Here the broken are healed, the weary refreshed, the dull excited, the weird accepted.

State convicts built a road through it in the 1930s. Hippies clustered here during the 1960s. Show-business stars have moved in since. Religions have been founded, taught, and deeply felt here. Songs have been written, and poems and great literature. Painters have been inspired, photographers challenged.

As unique and beautiful as it is, Big Sur is hard for some people to find. If you stand at one of the small stores or stations along Highway 1 long enough, you're bound to hear confused travelers ask, "Where is Big Sur?" or "How far to Big Sur?"

Nice people tell them they are in it. Pundits tell them they've been in it for half an hour. Tricksters will sometimes say it's forty miles down that way; just keep going and you can't miss it.

Exactly where Big Sur really is—and even what it really is—has always been a matter of definition. It has a ZIP code—93920—so you know it's a real place. But it's not incorporated in any legal sense; so different people put the actual "Big Sur" in different locations.

To many people, it's the River Inn, Pfeiffer Big Sur State Park, and the five-mile stretch of motels, campgrounds, and restaurants along Highway 1. It's the posh Ventana Inn to some, the simple Nepenthe restaurant to others, or the New-Age Esalen Institute to the south, the nineteenth-century lighthouse on Point Sur to the north, the graceful Bixby Bridge that's been used in hundreds of car commercials, or the 250 miles of hiking trails through the forests of the Santa Lucia Mountains.

It is all of those places, of course, and a fantastic array of hills, canyons, forests, meadows, rocks, capes, coves, rivers, trees, plants, and animals. Where the Big Sur Coast meets

the Pacific Ocean there are at least thirteen capes and rocky points that have been named over time, forty-one creeks and rivers that break up the cliffs and bluffs, seven coves and beaches big enough for landing ocean-going ships, and countless rocks and islands along the shore. No two of these places are ever the same and they are all worth exploring, again and again.

A walk in such natural wonder can change anyone's perspective.

The Spanish missionaries who settled in Monterey and Carmel in the eighteenth century named Big Sur *El Pais Grande del Sur,* "the big country to the south." It was virtually inaccessible and inhabited at the time only by the Esselen, a small tribe of Natives who traveled on the ridgelines so they could watch for grizzly bears.

The Esselen had lived in the area for about four thousand years, but they essentially disappeared after the Spanish arrived. The priests recruited or enslaved the Natives they found in California and used them as laborers to build the missions. Esselen who refused or escaped were hunted down by soldiers.

The Spanish were in the area about eighty years before settlers actually reached into Big Sur. After the California gold rush of 1849, some folks ventured into the rugged country and built the first cabins. They struggled with cattle and a semblance of farming in mountain country that required several days of horseback riding—or walking—to get to the nearest stores. Shipping ports were established at the turn of the twentieth century and a thriving timber industry exported redwood for lumber and tanoak bark for softening cowhides.

In 1919, hostelers and would-be resort developers convinced the state to build a highway to link the Monterey Peninsula with the Hearst Castle in San Simeon. It took eighteen years to blast through mountains, build enough bridges, and fill in coves where there were no mountain cliffs to hug. Highway 1 opened in 1937 and quickly became California's first designated scenic highway, as well as the most expensive road in the state to maintain. Winter rains frequently wash out whole sections of the road, actually closing it for months at a time. In such emergencies, stranded residents and visitors today are served more by helicopters than by horses.

This near-isolation helps hold the permanent population to approximately eight hundred. But it's an interesting collection made up of resort workers, celebrities, the retreating rich, environmentalists, ranchers, artists, pot growers, and hippies.

The breathtaking scenery alone attracts hundreds of thousands of tourists each year. The view from the highway is a feast for the eyes—a rocky coastline that juts out into the ocean like massive fingers; mountains that rise sharply from the sea; forests of vivid greens, reds, blacks, whites, and golds; shrubs with gnarled roots holding onto the hillsides; grasses that wave in the breezes; and open meadows so big that three hawks can cruise them at the same time.

When you stand on a ridgeline, you can see the land sloping down and going just as far as it wants to go. The ocean takes over from there.

Geologists tell us that Big Sur was actually formed in the opposite direction, that the land was pushed up from the floor of the ocean. They also explain that the granite foundations were formed about three hundred miles south of here in what is now the Sierra Nevada, then moved over millions of years on earthquake faults that are still moving them very, very slowly to the north.

A volcano made the forlorn Point Sur, the 350-foot-tall rock that has supported a landmark lighthouse since 1889.

Ponder any of the science if you want. Or just marvel at the results of it.

▷ *The brightly colored flower that gives Indian paintbrush its name decorates a row of green ferns laced by a little poison oak.*

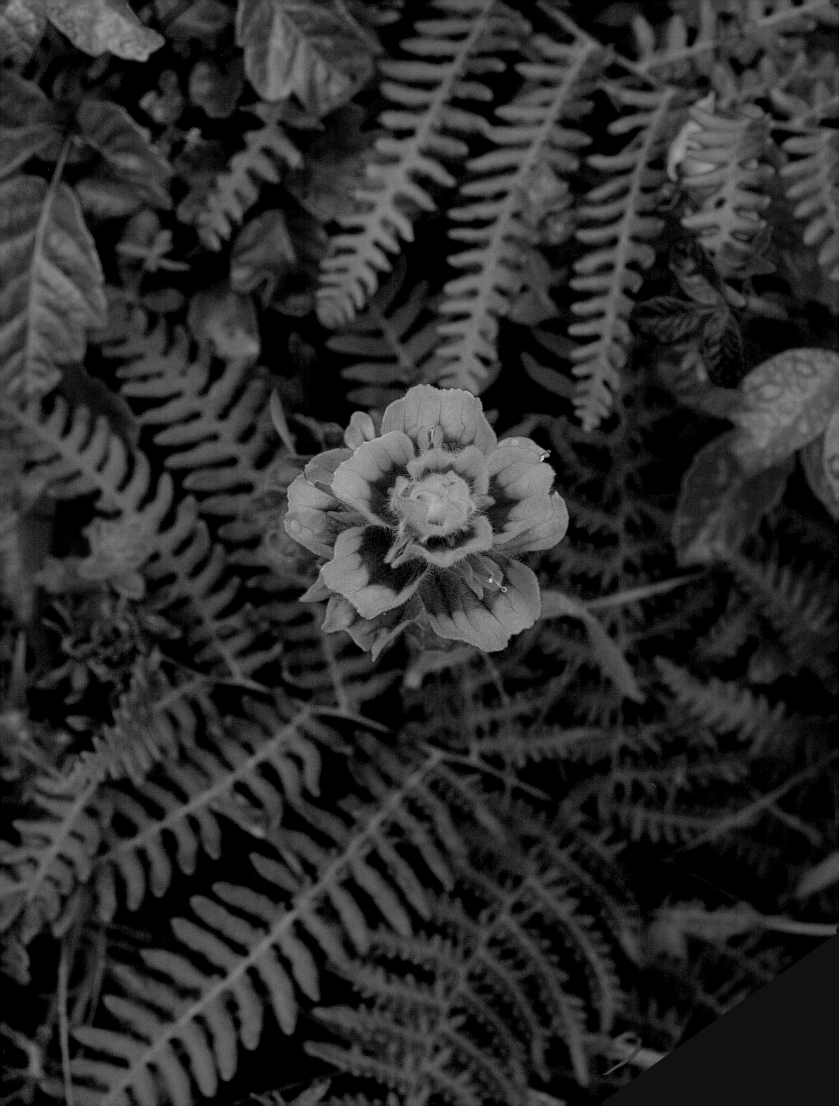

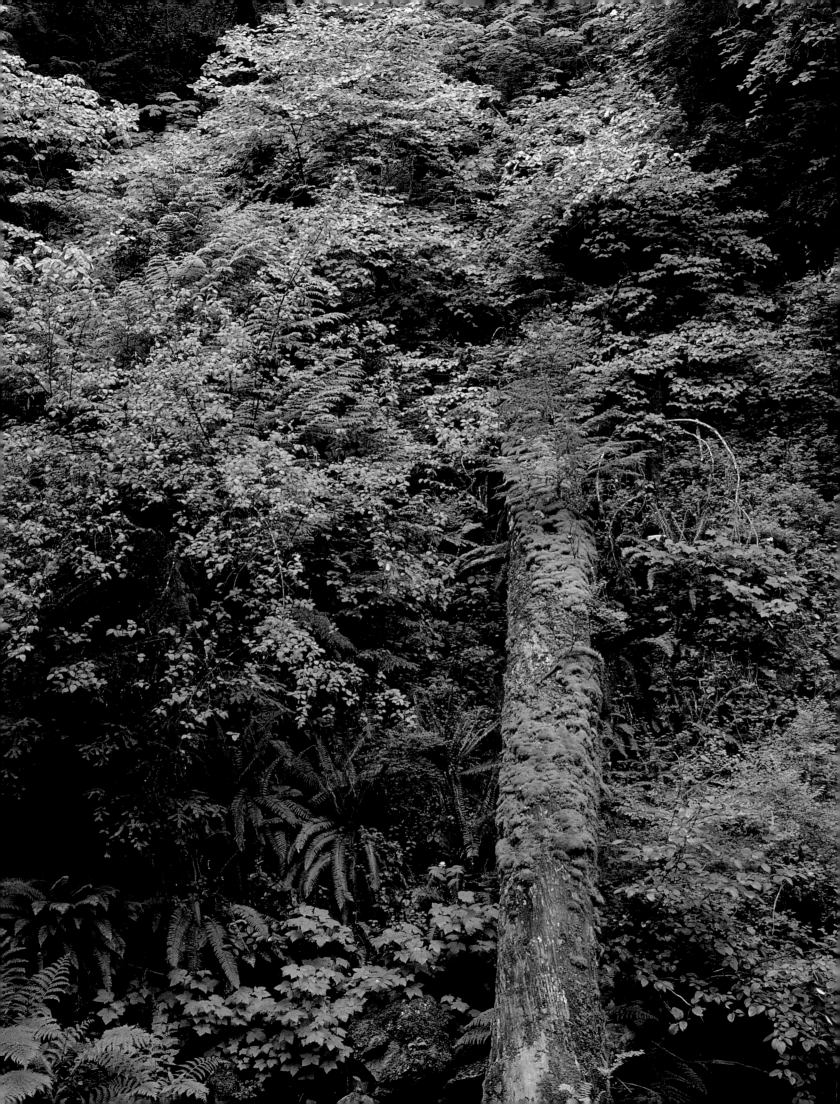

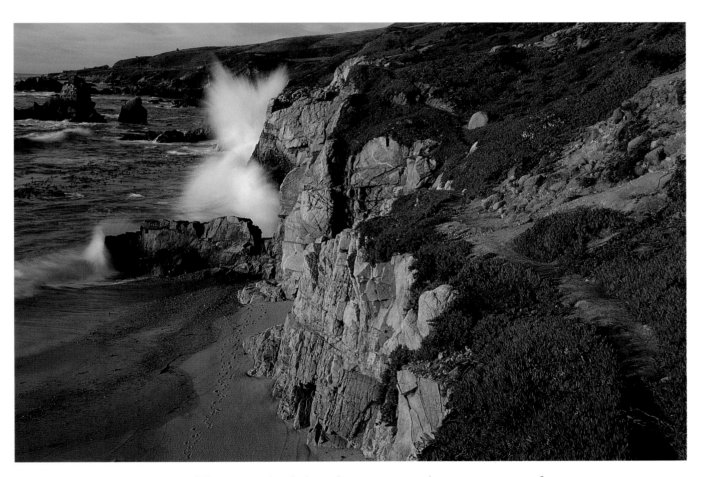

◁ A fallen tree, loaded with moss, stretches across one of the many creeks in Big Sur as ferns flourish near the water. △ Pacific Ocean waves explode high into the air as they smash into the rocky cliffs along the shore of Big Sur. It's a continual display, ever changing, always awesome.

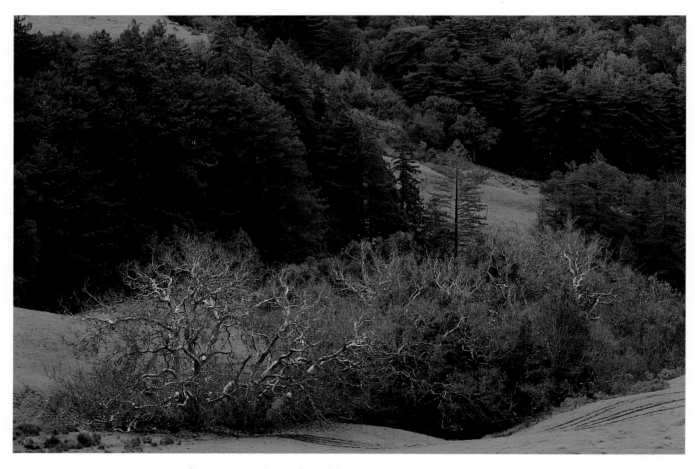

△ A forest scene along the Old Coast Road shows sycamore trees in the foreground giving way to redwoods that fill the hillsides. ▷ Fog obscures the top of a redwood forest at dawn. Even without the fog, it's difficult to see all the way to the tops of the tall trees while standing on the forest floor.

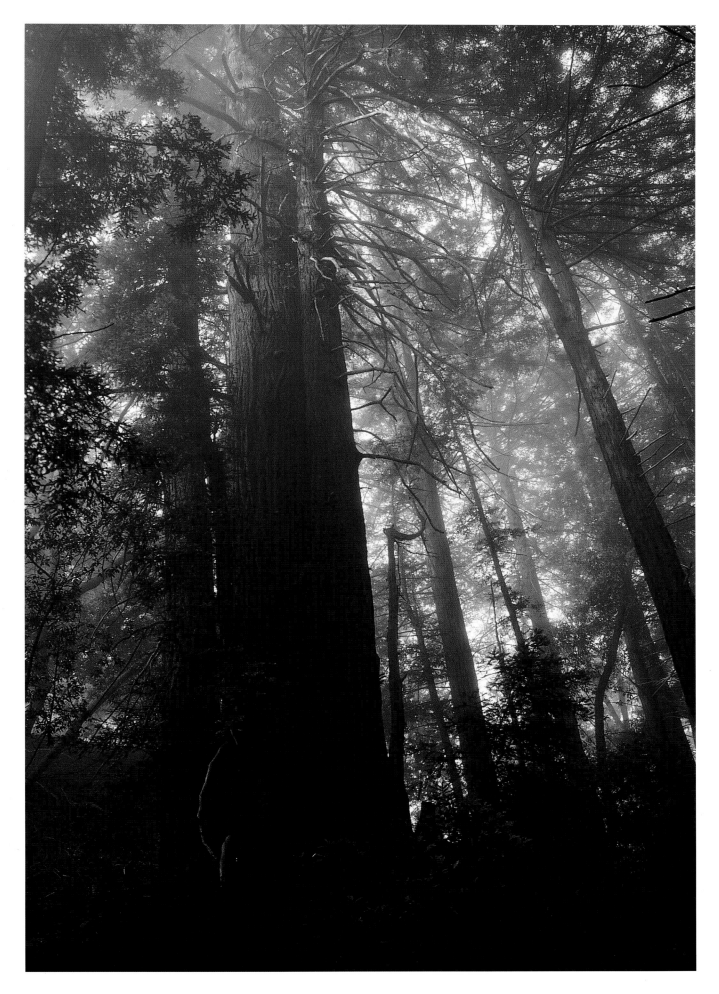

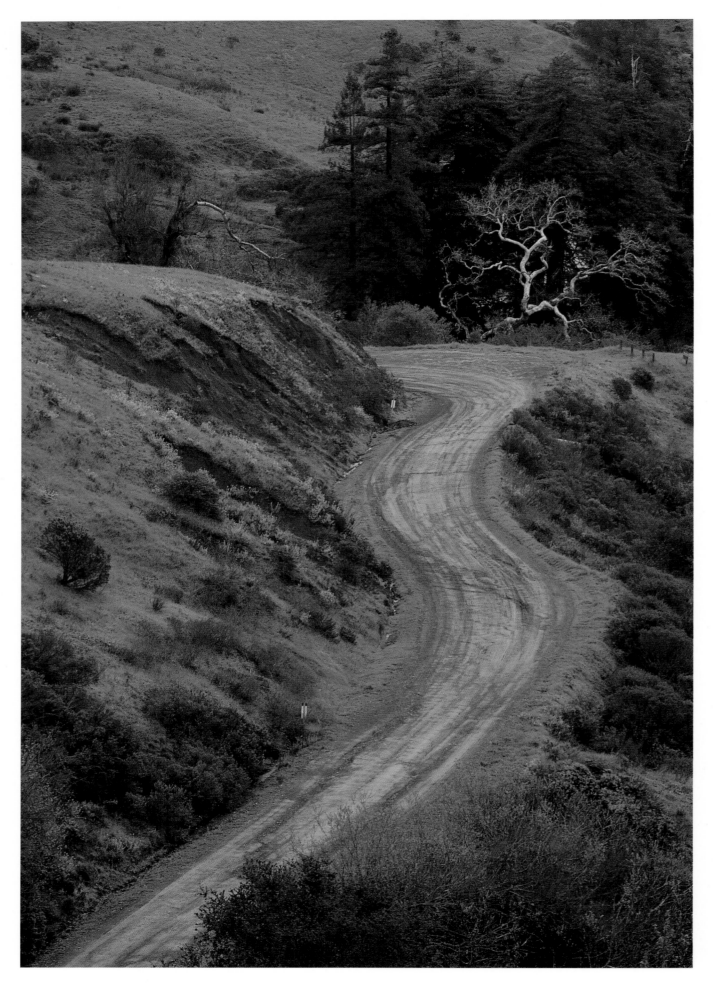

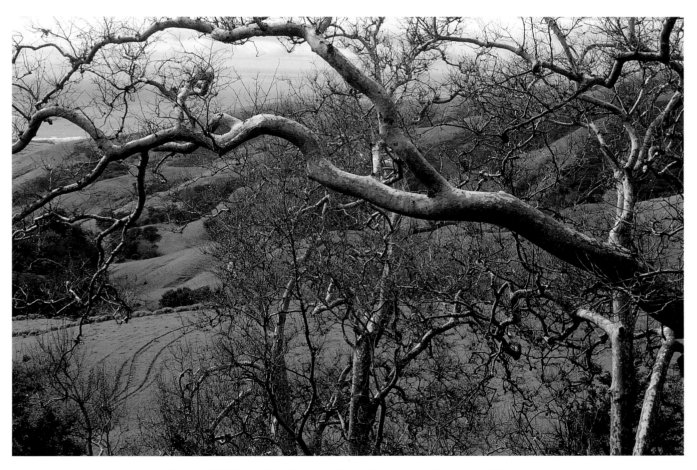

◁ The Old Coast Road, the original stagecoach road to Big Sur, winds around the hill after it leaves Highway 1, the modern roadway built by convicts and dynamite in the 1920s and 1930s.
△ The rolling hills of the Big Sur coast host a variety of trees, some changing with the seasons, some evergreens.

△ A rustic bridge, greened by moss and plants that flourish in the moisture, stretches across the Little Sur River to help hikers continue through the redwood forest off the Old Coast Road. ▷ Erosion alongside Highway 1 has created rocky spires that look like redwood treetops somehow petrified along the cliff's face.

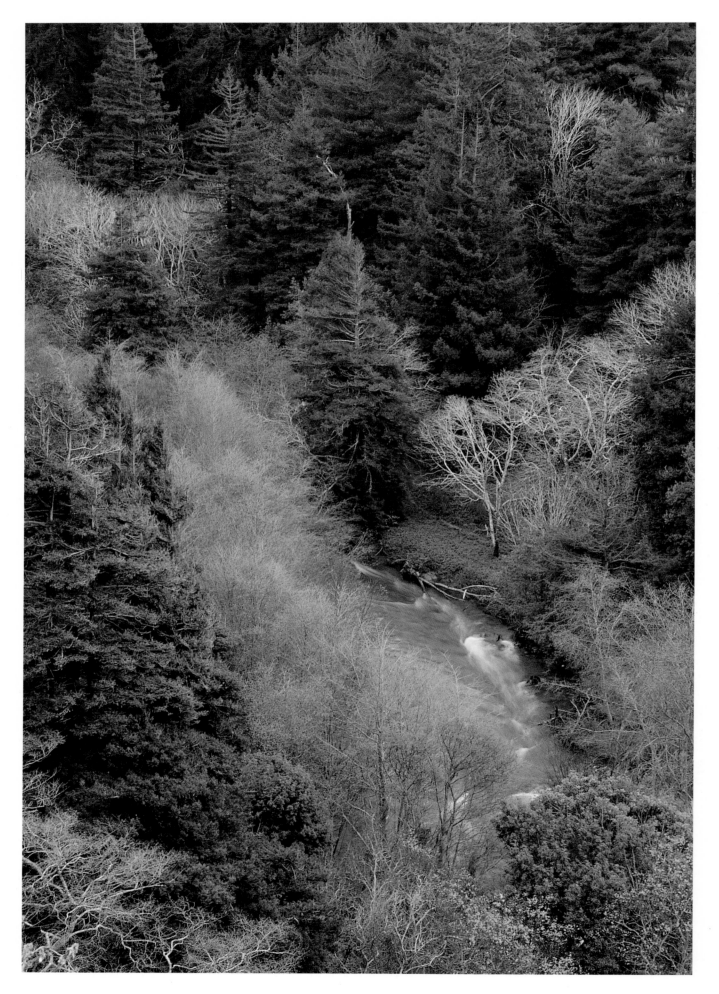

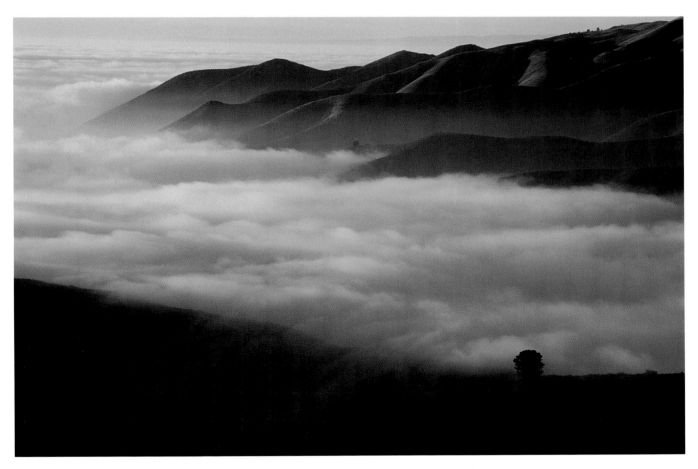

◁ The Little Sur River picks up speed as it follows the curves of the hills and splashes over the rocks on its journey to the ocean. △ The rolling hilltops of Big Sur hang above a thick fog that fills Palo Colorado Canyon on a summer day. This day, only one tree manages to poke through the fog.

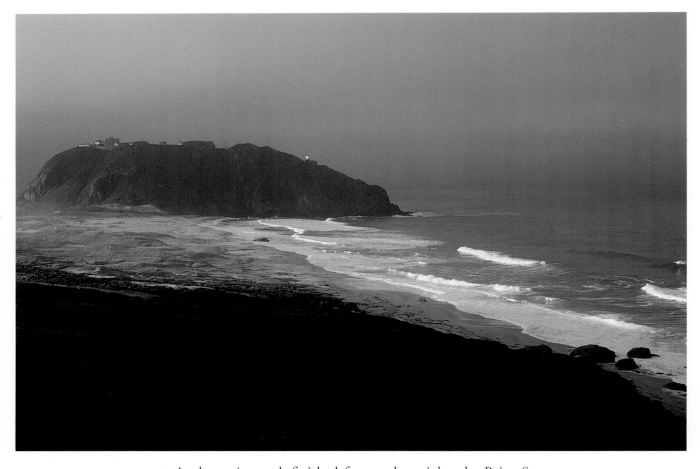

△ At dawn, its work finished for another night, the Point Sur Lightstation sits as a sentry on its namesake rock, just off a long, sandy beach continually washed by ocean waves. Built in 1889, the stone lighthouse is still in use. Maintained as a historic park by dedicated volunteers and the California Department of Parks and Recreation, it has been designated a national landmark.